Paint Pouring

Paint Pouring

MASTERING FLUID ART

By Rick Cheadle

Racehorse Publishing

Racehorse Publishing books may be purchased in bulk at special discounts for sales promotion, corporate gifts, fund-raising, or educational purposes. Special editions can also be created to specifications. For details, contact the Special Sales Department, Skyhorse Publishing, 307 West 36th Street, 11th Floor, New York, NY 10018 or info@skyhorsepublishing.com.

Racehorse Publishing™ is a pending trademark of Skyhorse Publishing, Inc.®, a Delaware corporation.

Visit our website at www.skyhorsepublishing.com.

10 9 8 7 6

Library of Congress Cataloging-in-Publication Data is available on file.

Cover design by Lori Wendin
Cover and interior photography by Rick Cheadle

Print ISBN: 978-1-63158-299-8
eBook ISBN: 978-1-63158-300-1

Printed in China

Contents

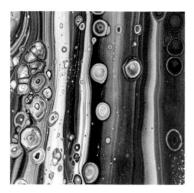

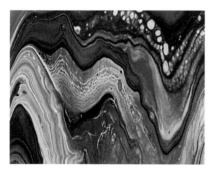

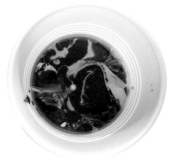

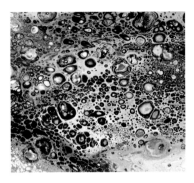

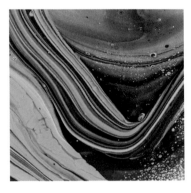

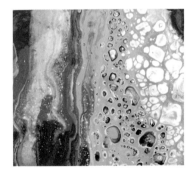

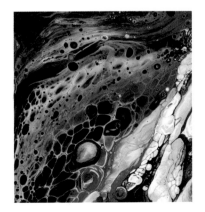

Legal Disclaimer

This book contains strategies, tips, and other artistic advice that—regardless of my own experiences and results—may not produce the same results for you. Consequently, I make no guarantees regarding the results you achieve. There are some materials used that may cause health problems and can be dangerous without taking proper precautions. You assume sole responsibility for the outcome of any application of information provided in this book.

Foreword

Who is Rick Cheadle?

When I began searching the Internet for articles, tutorials, and videos on the subject of poured acrylic paintings, Rick's name kept popping up among dozens of others. All artists were making names for themselves with this interesting art form. It took a while for me to start watching Rick's videos because I was attracted to videos where the artist talks throughout the process.

Rick doesn't talk much; at least, not in his videos. He teaches by placing instructive text at strategic locations in his videos and by personally demonstrating his techniques.

The majority of other artists' videos showed how to mix, layer, then pour the paints onto various substrates. However, they didn't address how to obtain consistent results in their desire to create "cells," which many beginners struggle with. As if he were reading our minds, Rick posted the outcome of his experiments with the different ingredients used to create mixtures that resulted in the almost-magical formation of cells, every time.

Rick, a successful self-taught artist with years of experience, knows the professional-grade art supplies he prefers are expensive and perhaps out of the price range for some beginners. To make this art form accessible to all, he began experimenting in his tutorials with house paints and inexpensive craft paints one can find at big-box hobby and "dollar" stores, letting his viewers know which ones worked or didn't.

An essential ingredient for creating cells in paint pouring is a dispersant, something that will cause the layered paints to rise to the surface and break into circles within circles of color. The body weight, or viscosity, of the layered paints determines which colors rise to the top the quickest, a process that needs a flow medium. A flow medium thins the paints without changing the strength of the colors. Rick tested all sorts of dispersants and mediums in his search for reliable substitutes for more costly materials.

His passion for art and his drive to spread that passion to others, his curiosity about how things work and desire for answers, as well as his inventiveness and strong entrepreneurial spirit all work to our benefit, helping us become the artists we dream of being.

To answer the question posed at the beginning of this introduction, I think Rick Cheadle is a modern renaissance person, an artist, a musician, a writer, an inventor, and a generous teacher.

M. C. McLemore
Pennsylvania, USA
July 2017

Author's Note

Dear Reader,

Thank you for purchasing my book *Paint Pouring: Mastering Fluid Art*. I believe the means of making art should be accessible to everyone, which is the guiding force behind writing this book. Poured fluid art is not a new idea, but the materials and techniques have been changed and adapted to meet the needs and methods of today's artists. I believe you will enjoy the process of poured painting and will be amazed at the results you can achieve.

This book outlines the steps I take when producing my poured acrylic paintings. I will share with you how I set up my studio, the materials I use in creating my art, and various techniques I employ in bringing them to a finished state. My book is meant to be a guide to help you learn what to do and, more important, what *not* to do.

By following the techniques outlined in this book, you will have enough knowledge to start making poured paintings of your own. As you know, nobody can guarantee your success in this field, but the methods revealed in this book will work for you if you apply them correctly. That's my promise.

So, are you ready? Great! Let's get started.

Happy Pouring!

Rick Cheadle

CHAPTER 1

A Very Brief History of Fluid Artists

David Alfaro Siqueiros (December 29, 1896 – January 6, 1974)

Siqueiros was a Mexican muralist who conceived a style of painting in the 1930s referred to as an *accidental painting*, in which he was able to create a variety of unexpected shapes and textures. He did this by layering different paints that had varying densities. Siqueiros introduced the use of nontraditional art materials (commercial art paints, industrial paints), techniques (using industrial paint sprayers, house paint brushes, spilled paint), and substrates (sides of commercial buildings, for example) to create his art. He was an early influence on American abstract artist Jackson Pollack.

> "The artist must paint as he would speak. I don't want people to speculate what I mean, I want them to understand."
>
> —DAVID ALFARO SIQUEIROS

Paul Jenkins (July 12, 1923 – June 9, 2012)

Jenkins was an American abstract expressionist painter who started paint pouring in the late 1950s. Paul Jenkins was an influential artist in the New York School as well as a vital presence in the development of abstract expressionism. I was fortunate enough to own one of his paintings (since sold) titled *Phenomena Jade Winds Walking*. He has been my major source of inspiration in my fluid painting art.

> "I try to paint like a crapshooter throwing dice, utilizing past experience and my knowledge of the odds, it's a big gamble, and that's why I love it."
>
> —PAUL JENKINS

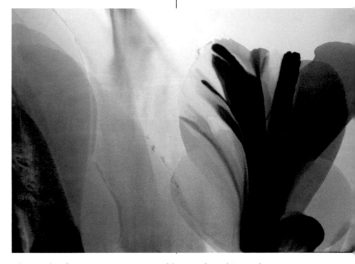

This is the first painting I owned by Paul Jenkins, *Phenomena Jade Winds Walking*, on a 6' x 10' canvas from 1977, pictured here (it was in my dining room). The canvas was so large I had to rent a U-Haul to transport it! Paul Jenkins often painted on large canvases like this. His dirty-pour "cups" were often made in full-size trash cans!

Other Artist Recommendations:

Helen Frankenthaler
Morris Louis
Jules Olitski
James Brooks
Sam Gilliam
Larry Poons

CHAPTER 2

Set Up Your Studio

First, We Must Talk Safety!

There are hazards involved with anything in life, and most problems can be avoided with a little knowledge and common sense. This is also true when it comes to creating art.

Most products you purchase for your paint-pouring endeavor will include instructions and safety recommendations. Read the SDS (Safety Data Sheet) thoroughly for the products you're using and follow these guidelines with great care.

Always use caution when using anything caustic and when using any type of flame. Never heat isopropyl alcohol and be careful not to burn your canvas, paint, or workspace. Off-gassing (the release of volatile organic compounds [VOCs] or other chemicals) is also hazardous. The silicone and all the stuff used in paint pouring wasn't made to be heated up, so use caution! Remember: *Always work in a well-ventilated area.*

Workplace essentials include the following:
- Safety glasses
- Protective clothing
- Latex gloves
- Respirator
- CO_2 (carbon monoxide) alarm
- Fire extinguisher

Prep Your Studio

Having the right tools and using the best materials you can afford is essential to your success as a fluid artist. If you plan on selling your work, it is especially important to use archival materials. This book will provide you with many alternatives. It is up to you to explore your options and decide what works best for you.

You can get as fancy and elaborate as you want with your workspace and tools. In the following sections, I have listed most of the items that I currently use or have used in the past. You can choose one item or all the items in each category, but remember that these are just recommendations. Eventually, you will start to get the feel for things and customize your paint pouring toolkit to your own personal style.

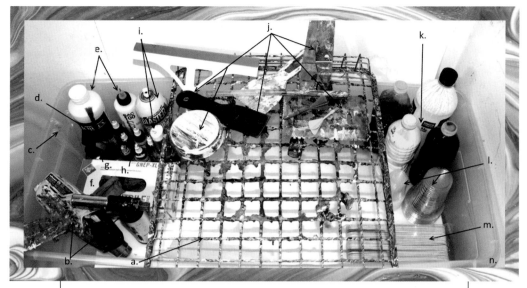

a. Wire rack
b. Heating tools
c. Pipettes
d. Brushes
e. Pouring mediums

f. Protective gloves
g. Liquid acrylics
h. High-flow acrylics
i. Cell creating additives
j. Swiping tools

k. Mixed paints
l. 9 oz. plastic cups
m. Craft sticks
n. Shallow tub

Work Surface

For your work surface, you will need the following:

• Sturdy and level table
• Drop cloth, plastic sheeting, or shower liner
• Shallow tub or bin with a lip to catch paint runoff (line bottom with freezer paper or Yupo paper or foam board to catch the paint runoff and make "paint skins")
• Rack (or cake turntable) to place your substrate on for painting

Alternative Set-Ups

Next, we will discuss inexpensive paint pouring setups. The left side of the photo below contains a wire rack that is flipped upside down. The total cost for this setup is $6. An even more inexpensive option is pictured on the right side of the image below. It consists of two types of aluminum pans. The total cost for this setup is $2. I use these setups when I do paint-pouring clinics.

"The studio, a room to which the artist consigns himself for life, is naturally important, not only as workplace, but as a source of inspiration. And it usually manages, one way or another, to turn up in his product."

—GRACE GLUECK

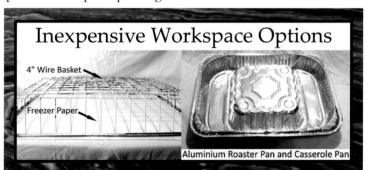

Inexpensive Workspace Options

4" Wire Basket

Freezer Paper

Aluminium Roaster Pan and Casserole Pan

Paints
(Recommended)

- Soft-bodied acrylic paints
- Heavy-bodied acrylic paints
- Fluid acrylics
- High-Flow acrylics
- Acrylic inks

"Things don't get tough in the studio. Sometimes things get tough outside the studio and going in the studio is a relief, a sanctuary, therapy."

—MARK KOSTABI

(Inexpensive Alternatives)

- Craft paints
- Latex house paint (flat or satin)
- Student-grade acrylic paints

Mediums and Alternatives

(Recommended)

- Pouring mediums (Examples are Golden GAC 100, Liquitex Pouring medium, or similar artist-quality acrylic mediums)
- PVA/Bookbinder's Glue (archival)
- Glazing medium
- Gloss medium
- Airbrush medium

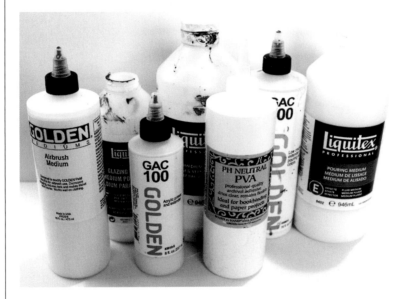

(Inexpensive Alternatives)

- Elmer's Glue-All
- Elmer's School Glue
- Floetrol (flow aid)
- Aleene's Original Tacky Glue
- Mod Podge

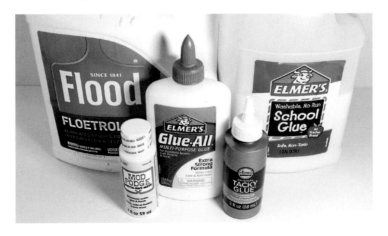

Substrates

- Canvas (including recycled canvases)
- Wood panel/hardboard/Easy Flow Panels
- Wood panel/hardboard cradled
- Yupo paper
- Mixed media paper
- Old CDs
- Old record albums
- Ceramic tiles
- Rocks and stones
- Old windows
- Furniture
- And more!

a. Stretched Canvas e. Yupo Paper
b. Vinyl Record f. Mixed Media Paper
c. Cradled Wood Panel g. Ceramic Tiles
d. Canvas Panel h. Masonite Board

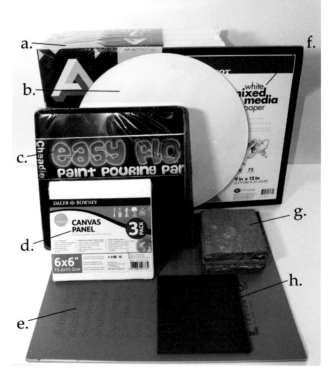

Please note: Regardless of what substrate you choose to paint on, I recommend at least two coats of gesso or paint primer be applied (and allowed to dry) prior to any paint pouring. Depending on how you want your piece to look, white primer base coat will make your art brighter, and a black primer base coat will make your colors richer.

Other Materials

- Pouring cups
 - ○ 3- or 5-ounce cups (or larger) for individual colors
 - ○ 9-ounce cups (or larger) for dirty pours
- Craft sticks
- Heat source (embossing tool, heat gun, or butane torch)
- Isopropyl alcohol
- Plastic condiment bottles with caps
- Pipettes (for adding small amounts of water to mix)
- Foam boards (to catch paint drippings and use in other projects)
- Paper towels
- Apron
- Protective gloves
- Variety of swiping and marbling tools (knockdown knife, taping knife, squeegees, scrapers, drywall tools, spatulas, among others)

Please note: Do not apply heat when using isopropyl alcohol.

Optional Additives (to aid in "cell" creation)

More research is required to test their archival quality, but the following additives have the potential to help you create perfect cells:

- Silicone lubricant (bottle or spray)
- Auto lubricant
- Hair or personal products that contain dimethicone

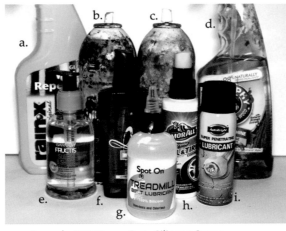

a. rain-x **b.** CRC Heavy Duty Silicone Spray
c. B'laster Silicone Spray **d.** Murphy Oil Soap
e. Fructis Sleek & Shine **f.** L'OREAL Extraordinary Oil
g. Spot On Treadmill Belt Lubricant
h. ArmorAll **i.** AutoBright Lubricant

. . . And one more thing:

An Art Journal

Writing while creating clarifies and focuses our minds. Every time we try something new, make a new discovery, or totally ruin a new canvas, it is all part of the process. Keeping track of your wins and losses is also part of the journey.

Before I videotaped my art sessions, I kept a journal of everything that worked and what didn't. Now I record everything, so I don't make as frequent journal entries, but I still do it!

CHAPTER 3

Prepare Your Paints

Mixing Ratio Essentials

The consistency of all your paints is the essential element in assuring a successful pour. Properly mixed paint should flow in a steady stream, as in the photo below.

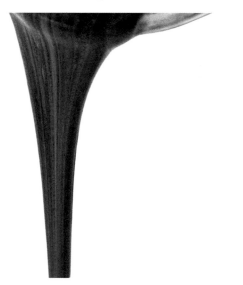

In this book, I will show you how I personally achieve the proper fluidity that gives consistent results for me, the students in my classes, and countless other paint-pouring enthusiasts that I hear from daily.

I recently conducted an experiment where I spent ten dollars at a dollar store on paints, pouring medium alternatives (Elmer's Glue), and other supplies. I utilized my own "mixology" and had amazing results. Give my "Budget Mix" a chance, as it is easy to create and it doesn't cost much money. Remember, this is for practice purposes. Please note that the materials used for the Budget Mix are not archival and will not stand the test of time.

I like to keep things simple, especially when learning something new. My recommendation is to find one mix (recipe) and develop your concoction around that. Over time, I have developed an intuitive sense of how things work together, so I don't measure or weigh anything anymore. Mixing and stirring each individual color takes long enough, so I certainly don't want to add more steps and time into that process.

My Mixology

In the following section, I will discuss how to create various paint-pouring mixes as well as their benefits, downfalls, and archival quality.

Fine Art Mix (archival)

This is my go-to recipe that I use in my paint-pouring art that is sold to collectors and offered at art shows and in art galleries:

- 9 fluid ounces Liquitex Pouring Medium
- 2 fluid ounces Liquitex Gloss Medium
- 2 fluid ounces Floetrol
- 4 fluid ounces distilled water
- 1–2 fluid ounces GOLDEN GAC 800

This "Fine Art Mix" is the "vehicle" (see diagram to the right) by which your paints are delivered to the canvas. Once you finish mixing a batch of your Fine Art Mix, you can then add paint into their individual containers. The amount of paint depends on the paint type, opacity, and density.

Paint-to-Fine Art Mix Ratios

The following table contains the amounts of paint I add to my paint-pouring mixture. I would use this as reference and adjust accordingly. Also keep in mind the soft and heavy-bodied acrylics may require more distilled water added to the mixture to get the correct consistency.

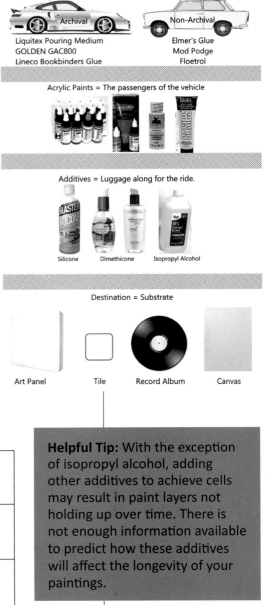

Making Sense Of Pouring Mediums and Additives In Relation To Acrylic Paints in Fluid Art/Paint Pours

Pouring Medium = The vehicle by which the color/paint is delivered

Archival — Liquitex Pouring Medium, GOLDEN GAC800, Lineco Bookbinders Glue

Non-Archival — Elmer's Glue, Mod Podge, Floetrol

Acrylic Paints = The passengers of the vehicle

Additives = Luggage along for the ride.

Silicone Dimethicone Isopropyl Alcohol

Destination = Substrate

Art Panel Tile Record Album Canvas

Helpful Tip: With the exception of isopropyl alcohol, adding other additives to achieve cells may result in paint layers not holding up over time. There is not enough information available to predict how these additives will affect the longevity of your paintings.

Acrylic Ink	3–10 percent paint to 90–97 percent Fine Art Mix
High-Flow Acrylics	5–10 percent paint to 90–95 percent Fine Art Mix
Fluid Acrylics	5–15 percent paint to 85–95 percent Fine Art Mix
Soft-Bodied Acrylics	50–60 percent paint to 40–50 percent Fine Art Mix
Heavy-Bodied Acrylics	75–85 percent paint to 15–25 percent Fine Art Mix

Paint Type Mixing Ratios

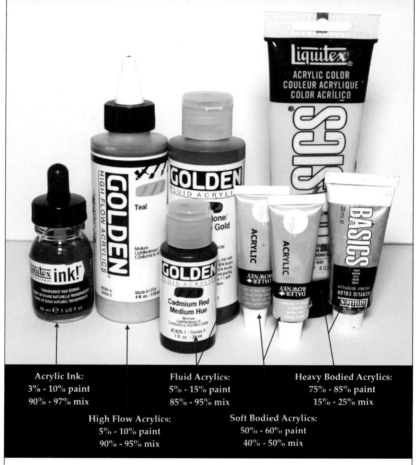

Acrylic Ink:
3% - 10% paint
90% - 97% mix

Fluid Acrylics:
5% - 15% paint
85% - 95% mix

Heavy Bodied Acrylics:
75% - 85% paint
15% - 25% mix

High Flow Acrylics:
5% - 10% paint
90% - 95% mix

Soft Bodied Acrylics:
50% - 60% paint
40% - 50% mix

Other Mixes

Budget Mix (Elmer's School Glue) (nonarchival)

This is the mix I use when doing demonstrations and teaching classes. Add 1 part acrylic paint to 1 part School Glue, mix well; add water to reach desired consistency.

Budget Mix (Elmer's Glue-All *) (nonarchival)

Mix ¼ cup (2 fluid ounces) acrylic paint to ¾ cup (6 fluid ounces) Glue-All mix.

Floetrol Mix

4 parts Floetrol with 1 part highly pigmented fluid acrylics, *or* 1 part Floetrol with 2 parts heavy-body acrylic paints.

* Glue-All: I mix ¾ cup glue to ¼ cup water.

One Size Does Not Fit All!

There are many variables to consider when following a paint pour "recipe":

- Climate (temperature/humidity)
- Paint brands
- Paint types (fluid, soft-body, house paint, etc.)
- Paint opacity
- Water used (different pH levels, distilled, tap water)
- Water temperature
- Types and brands of additives used (pouring medium, PVA, bookbinder's glue, silicones, dimethicone, etc.)

I recommend that all artists experiment, take notes (as I previously mentioned, I keep a journal in my studio), and figure out what works for them and what doesn't.

Helpful Tip: I recommend covering your mixed paints and letting them sit overnight to rid the paint of any air bubbles. This will ensure smooth lines and an overall better-looking result in your pours.

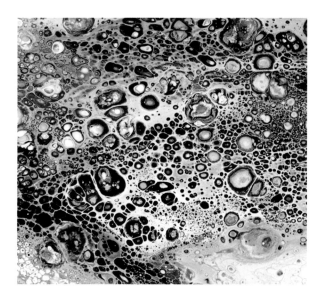

A Word about Cell Creation

One of the most frequent questions I receive is "How do I make cells?" My longstanding opinion is that it's all about the fluidity of each individual color and how they react with one another. This is what I have found to be fundamental in cell creation.

However, acrylic paint colors and their relative densities are also important. When I am creating a pour, I am thinking in terms of "How do I make the light layers break away from the darker colors and help them rise up and through to create cells?"

If you have the appropriate consistencies, and understand the paints' densities and how they react with one another, it's a beautiful thing to watch the cells form. They form almost as if by magic. Keep in mind every brand of acrylic paint will have its own unique characteristics and you will have to experiment to see what works best for your style of fluid art.

Silicone and alcohol do make a difference, but they are not a requirement for cell creation. It is also important to note that there are no known studies available in regard to silicone or any other nondrying oils and how they react within the acrylic paint mixtures (long-term). Therefore, I only recommend using alcohol as an additive to be certain of your painting being archival.

> **Helpful Tip:** On the occasions that I create a nonarchival piece I am fond of, and I believe would be well received at galleries, I have a giclée print made. See the giclée printing section at the end of Chapter 9.

The following chart is a helpful guide that I use for reference. The paints in this chart are the acrylic paints that come in tubes and are not high-flow types of paints. As stated earlier, all brands have varying densities, so I recommend experimenting and making your own chart based on the paints that you use. This is not a scientific guide, so there is no guarantee of its accuracy.

Colors	Density / Characteristics
Fluorescent Colors	Thinner Density
Quinacridone Violet	
Quinacridone Magenta	more
Nickel Azo Yellow	transparent
Quinacridone Red	
Phthalo Green	
Ultramarine Blue	
Ultramarine Violet	
Burnt Sienna	
Burnt Umber	
Raw Sienna	neutrals
Cobalt Blue	
Raw Umber	
Cadmium Yellow	Thicker Density
Mars Black	
Cerulean Blue Deep	
Cobalt Turquoise	more
Cadmium Red Dark	opaque
Cobalt Green	
Cadmium Orange	
Cadmium Red	
Titanium and Zinc White	

Opaque, **translucent**, and **transparent** are terms used to describe the way paint reacts to light.

Opaque

Opaque paints are heavier in density and don't allow light to pass through them. The light bounces back, so therefore you cannot see through opaque paints.

Translucent

Translucent paints are less dense than opaque paints and do transmit light, but the light is scattered as it goes through, giving it a frosted appearance.

Transparent

Transparent paints are lightest in density and allow light to go through to the layers beneath. It can appear almost as clear as glass. An example of this is the clear varnish you apply to your painting after it has dried. Clear coatings do not alter the colors they cover.

Another example would be paint colors listed as transparent that allow you to see the colors laid down first. A transparent paint layer will alter the appearance of the color underneath it. For instance, yellow over blue will reflect green.

The example below demonstrates the qualities of opaque, translucent, and transparent.

Paint Opacity Comparison

Opaque Translucent Transparent

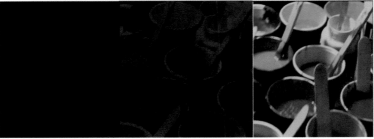

Color Theory
First, The Color Wheel

I recommend that beginners purchase a color wheel. Color wheels can be found online and in art supply and book stores, among other places. They help beginners grasp color theory and why certain colors work together and why others don't.

Using a color wheel will improve your color selection for each painting and will help you understand the concepts of balance and harmony in creating art. They explain the basics of color mixing and relationships: primary colors (red, yellow, and blue), which are pure colors that cannot be made by mixing colors

together; secondary colors (orange, green, and purple/violet) which are created by mixing two primaries together; and so on.

COLOR WHEEL

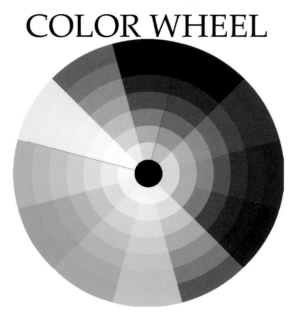

Balance

Even though many times our paint pours are considered random, it is possible—and you are encouraged to try—to keep balance in your work. That is why the way you tip the canvas and the way you swipe all play a role in the look of your piece.

Are the colors balanced? Are the design elements flowing? These are all things to consider while manipulating your paint.

Harmony

Does everything in your artwork work together? Is there "that one spot" you're just not happy with?

There are many aspects to consider: forms, spaces, color harmony, the flow or rhythm, and the movement of the elements all play a factor in a harmonious painting.

Remember, after your paint pour dries, you can add embellishments and bring it all together to make it work. The pour doesn't have to be the end of the story. A lot of times, in my case, it is the beginning of the story.

Composition

When done correctly, a good composition will draw your viewer in and keep their eyes moving across the whole canvas.

CHAPTER 4

Know the Techniques

In a poured painting, there are a variety of ways to apply paint without using brushes or any other traditional tools. Paint-pouring pioneer Paul Jenkins used trash cans to pour onto his canvases. However, the techniques discussed in this book are for paintings of a much smaller scale. At some point in your fluid-art career, the scale of the canvas you use might call for a larger cup, perhaps even a half-gallon pitcher! However, I recommend you start off smaller until you can judge the volume of paints and additives and the size of tools a larger substrate requires. In this section, I will discuss of variety of pours and techniques that have varying results.

An important note about the preparation of the pours: when describing the combining of the ingredients for each technique, I will use the description "additive."

The term additive describes the materials that can be added to your mixes to create cellular patterns in your paintings. These additives include isopropyl alcohol, liquid silicone, spray silicone, personal lubricants, and hair products that contain dimethicone in the ingredients.

These additives are optional. They are not required to create beautiful paintings, but they are ingredients that I personally use, so I have included them throughout this book.

> **Helpful Tip:** I cannot stress enough that when using isopropyl alcohol, **do not add heat**. When I mention "adding heat" in my instruction, keep in mind that this phrase does not apply to alcohol! I only add heat to the other additives. It is imperative to have proper ventilation and safety measures in order.

Basic Techniques
Dirty Pour
Layers of paints poured on top of one another in the same cup makes a "dirty pour" cup. I try always to include white in every pour, usually beginning my paint layering in the dirty pour cup with Zinc or Titanium White. I do this because white is the heaviest paint, and it sinks to the bottom once the cup has been flipped on to the canvas. This causes many interesting effects including lacing, webbing, and the creation of cells.

Familiarizing yourself with paint transparency and opacity is helpful when deciding on what order to pour your paints into the dirty pour cup.

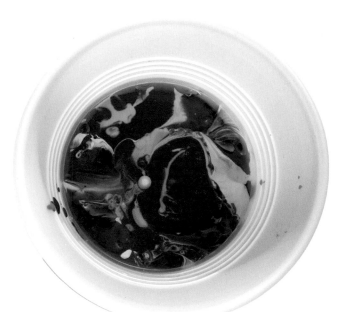

A Look Inside a Dirty Pour Cup.

Creating the Dirty Pour

As previously stated, begin with white paint. Pour in an ounce or so to cover the bottom of the cup, then spray or drip your additive of choice. Once you've done that, start adding layers of color. I usually pour two to three colors, then add more white paint, more additive, more colors, and so on. I do things randomly and often experiment, so keep in mind that there is no rhyme or reason for the order I pour paints into the cup.

I average around five to seven squirts or drops of additive per nine-ounce dirty pour cup. (For reference: a full nine-ounce dirty pour cup will generally cover a fifteen-by-fifteen-inch canvas, depending on the thickness of your paint. If your canvas is smaller or larger, adjust your dirty pour paint volume accordingly.) After filling your cup with all the layers of paint, stir the dirty pour cup very little, if at all. If you do decide to stir, make sure not to overdo it because you want to maintain the separation of colors and avoid creating "muddy" colors.

Once you have all your colors layered in a cup, pour onto the substrate of your choice (for the remainder of the book, I will refer to substrates as "canvas"). At this point, you can move and tilt the canvas to manipulate the paints.

Tipping the canvas allows paint to cover the whole surface (or nearly all of it), letting excess paint run over the edges. This method gives the artwork a "flowing" appearance, which is very popular with many artists. There are numerous ways to manipulate

the paint and create more design elements like scraping, swiping, and skimming, which I will cover later in this chapter.

Once the canvas is covered, touch up the sides with the paint runoff. When you have complete coverage and are happy with the composition of the painting, introduce heat by using a chef's torch or a heat gun. The heat is what helps generate cellular activity in the work. The oils from the additives react with the heat and create cells. To reiterate: always use caution when heating up your art and never heat alcohol. Please follow all the safety recommendations discussed on page 3.

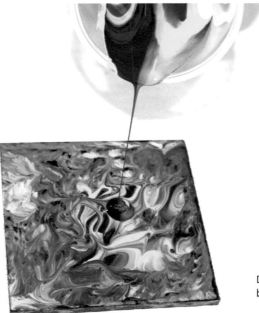

Dirty Pour cup being poured.

Flip Cup

The "flip" cup is prepared exactly like a dirty pour in terms of mixing and layering the paints and additives. The flip cup technique is more of a description of how you get the paint on the surface of your canvas. In short, you flip it over.

While holding the dirty pour cup (which is sitting on your workspace) with your left hand, pick up the canvas with your right hand and place the canvas face down over the cup opening. Then carefully pick up both the cup and canvas (while holding the cup tightly against the canvas) and flip them over so that the canvas is now on the workspace with the cup sitting atop the canvas. I usually let the cup sit on the canvas for twenty to thirty seconds to allow the dirty pour contents to settle. Then, with one motion, remove the cup from the canvas; all the paint should pour out onto the canvas.

At this point, move and tilt the canvas around to cover the canvas with paint. Once the canvas is covered, touch up the sides

with the paint runoff. When you have complete coverage and are happy with the composition of the painting, introduce heat by using a chef's torch or a heat gun. Again, always use caution when heating up your art and never heat alcohol. Please follow all the safety recommendations discussed on page 3.

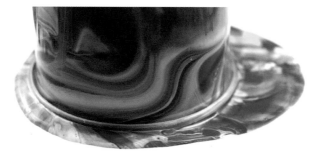

Flip Cup on Easy Flow Panel

A Few Variations on the Basic Techniques

The Reserve Flip Cup

Basically, the reserve flip cup is prepared exactly as a flip cup pour, but instead of emptying all the paint on the canvas, you use a quick motion when lifting to save some of the dirty pour mixture at the bottom of the cup to later cover the corners and edges.

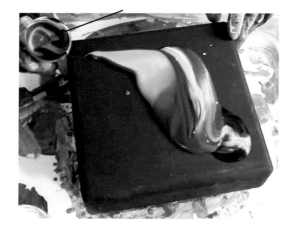

Reserve Flip Cup Pour: Flip cup over quickly and keep enough paint in the bottom of the cup to ensure full coverage of corners and edges.

The Flip and Drag

This is a technique I sometimes use prior to lifting a flip cup off the canvas. Basically, I flip the cup onto the canvas. With the canvas sitting on the rack, I simply slide the cup around the surface of the canvas, making sure I get close to all four corners. My thought with this is that it will help with the flow of the paint over the edges and corners upon lifting the cup.

A popular variation of this (championed by artist Ann Osborne) is to do the traditional flip cup with a slight addition. Prior to dragging across the canvas, pour white paint onto the canvas, around the cup, and into the corners so that when you

drag the cup, the dirty pour cup paints incorporate into the white paint, creating a dynamic look. Look for Ann on YouTube. She does great work.

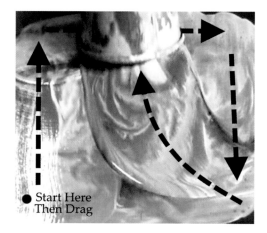

The "Flip and Drag" Technique.

Puddle Pour

"Puddle" pours are a layering of color(s) on the canvas in one or more puddles, which allows the paints to flow out and/or into one another. When there is enough paint on the surface, tip the canvas, and, depending on the degree of the tilt, the colors will disperse and create designs and unique color combinations throughout the canvas.

A variation of this technique is a puddle pour with void fill. A puddle pour, but with an added pour covering the blank spots of the canvas. Once the canvas is covered, touch up the sides with the paint runoff.

When I have complete coverage and I'm happy with the composition of the painting, I will introduce heat by using a chef's torch or a heat gun. The heat is what helps generate cellular activity in the work. The oils from the additives react with the heat and create cells. Always use caution when heating up your art and never heat alcohol. Please follow all the safety recommendations discussed on page 3.

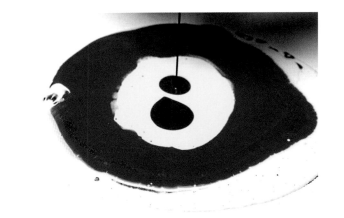

Puddle Pour

Open Cylinder

This method employs a bottomless cup. Artist Andy Drop was the first creator I saw using this method. The idea here is to do a self-contained dirty pour that isn't actually poured. The bottomless cup or container is a vessel that keeps the paints inside, allowing for tons of unique possibilities and color combinations once the cup is lifted from the canvas. I like this type of pour on small canvases, but I mostly use it on extra-large canvases when I need more precise color placement.

As with the previous techniques, once the canvas is covered, I touch up the sides with the paint runoff. If I like what I see, I will apply heat, as described previously, to facilitate the development of cells.

Always use caution when heating up your art. Please follow all the safety recommendations discussed earlier in the book. (I'm going to keep writing this until you start repeating it in your sleep because it is that important!)

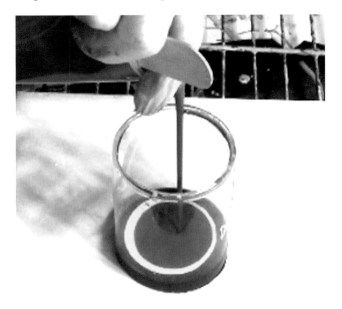

"Open Cylinder" Pour

Ribbon Pour

I like to use this technique at the end of the paint-pouring session when I have several colors left over from what I poured that day. Sometimes I've used as many as twelve colors in a ribbon pour!

Depending on how much paint I have and what size canvas I am using, I pour the mix directly on the canvas. Sometimes I will pour a thin layer of Zinc White or Titanium White down first. When pouring the paint, I try to be loose, pouring in a free-flowing motion, creating a taffy- or ribbon-like appearance with the paints. When doing these types of pours, keep the tipping of the canvas to a minimum.

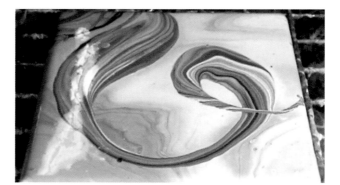

The "ribbon" pour technique on an Easy Flow Panel.

Swipe Technique

Pick three to five colors for the background colors. Then mix them according to my mixology and put one to two squirts or drops of additive in each color. Pour the three to five colors on the canvas in a striped pattern, occasionally crossing over one another, but not too much. At this point, tip the canvas to spread out all the paints. Once you have the canvas covered in your background colors, introduce the swipe-over color. Use either white or black to do the swipeover. Make sure that the swiping color is slightly thinner than the other paints. I usually add silicone to the swiping colors, but sometimes I don't (I'm always experimenting).

Always start at the end of the canvas that you like the least. Pour a strip of paint from corner to corner approximately one to three inches wide, depending on the size of the canvas. Another guide is to cover 10 to 20 percent of one end of the canvas. Then take heavy card stock, a three-milliliter laminating sheet, paper bag, or something similar and begin swiping the white paint over the initial layers that were poured. I sometimes increase the white and repeat the process over the whole canvas until I get the look I'm trying to achieve.

Doing these swiping motions should generate many cells when done correctly. Getting a feel for the swipe is the key. You want to lightly skim the heavy card stock or your choice

of a similar medium over the paints. This takes practice, but it is worth the time to get it right.

Pictured is a large canvas ready for the swipe technique, which has six colors plus white. I normally only use three to five colors, but this piece was larger than what I usually work with. Notice how the white covers the bottom 10 percent of the canvas. This is the "swipeover" color.

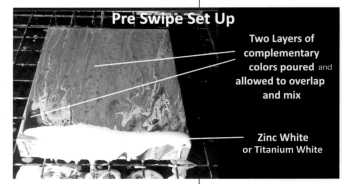

Pre Swipe Set Up

Two Layers of complementary colors poured and allowed to overlap and mix

Zinc White or Titanium White

Swipe with Knockdown Knife

Sometimes a pour doesn't go as planned. Sometimes the colors run together and make "mud," sometimes the colors aren't quite right, or sometimes I'm just not feeling it. Well, that's the time when I break out the knockdown knife. For this technique, I base my swiping color on what colors I will be swiping over.

For example, if the colors are bright and cheerful, swipe with black paint. If the colors are drab or muted, swipe with white paint. I always think in terms of balance in my paintings. Pick your least favorite end of the canvas, lay out your swiping paint (white, black, or any color you like), and pour it directly on the poured canvas that you are swiping over from corner to corner.

The amount of paint is approximately one to three inches in width, depending on the size of the canvas. Then take the knockdown knife and, with a light touch, skim the top of the poured paint and pull it down the length of the canvas. This takes a lot of practice to get it right, but once you get it down, you'll love it. In fact, I have students that only use the swiping technique.

"Swiping" technique with a knockdown knife.

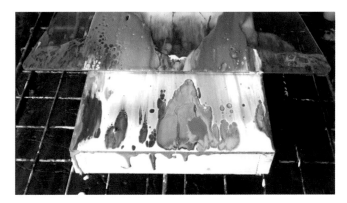

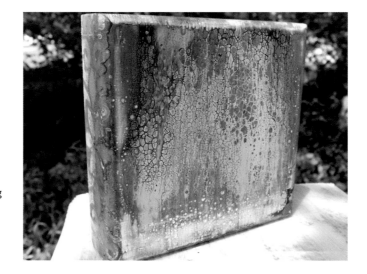

This piece was made using the swipe technique with a knockdown knife.

Multiswipe with Spatula

The way I usually do this type of swipe is as follows: I pick three to five colors for the background colors, mix them according to my mixology, and put one to two squirts or drops of additive in each color. I then pour the three to five colors all over the canvas in a random fashion, occasionally crossing over each other, but not too much. At this point, I tip the canvas to spread all the paints out over the canvas.

Once the canvas is covered in my background colors, I introduce the swipeover color. I use either white or black to do the swipeover (I usually add silicone to either of these colors, but sometimes I choose to omit this ingredient). I always start at the end that I like the least and pour a strip of paint from corner to corner approximately one to three inches wide, depending on the size of the canvas.

Then, I take a spatula and begin swiping the white or black paint over the initial paints that were poured. I sometimes add more of the white or black paint, repeating the process over the whole canvas until I get the look I'm trying to achieve. These swiping motions should generate many cells when done correctly.

Getting a feel for the swipe is the key. You want to gently skim the spatula lightly over the paints. This takes practice, but the time spent to get this right is not misspent. I have saved many bad pours by utilizing this technique.

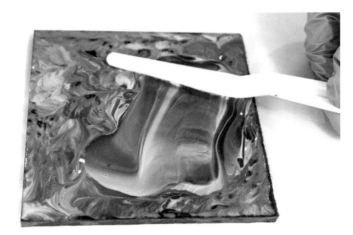

Swipe Technique
with Spatula

Multilayer

Begin with picking out your colors and then start layering them in various patterns on top of one another, keeping in mind not to pour too much paint on the surface (too much paint increases the chance of cracks to form).

Once you have the whole canvas covered, then pour either a single color or a dirty pour directly on the prepoured canvas. I like to do this in a flowing, swirling-type pattern and just let the paint do its thing. Too much tipping and tilting of the canvas at this point will dissipate what you have created with the overpour.

However, if you are unhappy with the results of that added layer, you can tip the canvas and let the paint run off and try again or use my go-to solution when I'm just not happy with what I'm seeing: swipe it!

Example of a "multilayer" pour. The art to the right was made with a four-color dirty pour followed by heating the surface to create the cells. Finished with another dirty cup pour with three colors (poured over the still-wet first layer). This piece took three days to dry, and I allowed a month to cure before sealing with resin.

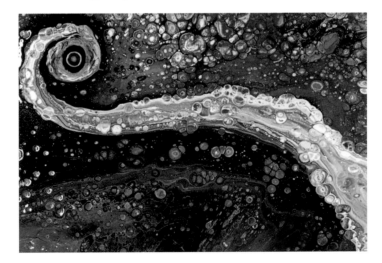

Dip and Swipe

This effect is accomplished using the runoff paint from previous pours. Dip the canvas into the collected puddles of paint, then, using the swiping tool of your choice, perform one or multiple swipes until the desired result is achieved.

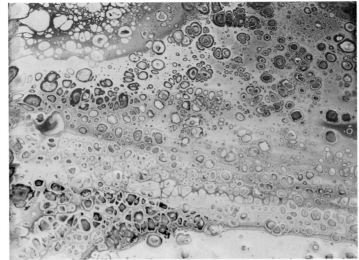

This is an example of a "dip and swipe." Notice the black of the Easy Flow Panel coming through. This look was accomplished with two swipes of a drywall trowel.

Dip and Pour Over

Use the runoff paint from previous pours by dipping the canvas into the collected runoff paint. Then, using a dirty pour or a single-color cup, pour directly on top of the dipped canvas surface. From this point, you can tip, tilt, and manipulate the paint into the desired look, or you can use swiping tools for an even more dramatic effect.

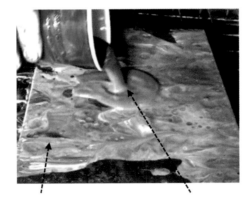

1. Canvas has been dipped into paint runoff from previous pours.

2. New mix of colors are poured directly on top.

Dip, Pour, and Swipe

1. Dip canvas into paint runoff. **2.** Do a puddle pour at one end of the canvas.

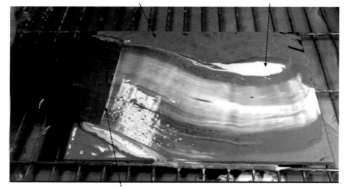

Canvas dipped, poured-over, and then swiped.

3. Do a swipe using your favorite tool.

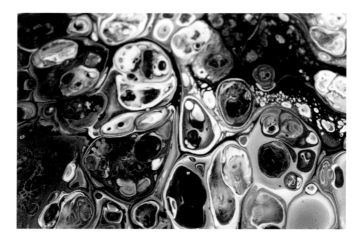

Reshugah (2017) by Rick Cheadle, created using the dip, pour, and swipe method.

Airblown

For this technique, pick out your colors and either pour single colors all over the canvas or combine in a dirty pour cup. The way I typically choose colors for these types of pours is to pick my favorite analogous color scheme (three adjacent colors on the color wheel) for the first pour, then add three complementary colors and blow on those three added colors.

An example would be to have a base coat of yellow, yellow-green, and green poured all over and covering the canvas. Then using the complementary color red-violet, pour puddles wherever you think it's appropriate, keeping in mind basic design elements like composition, balance, etc.

Once all the colors have been poured onto the canvas surface, then introduce air. I use a computer duster tube, but a straw or an air compressor will do. The idea here is to blow air onto the canvas and manipulate the paints to create unique patterns and designs.

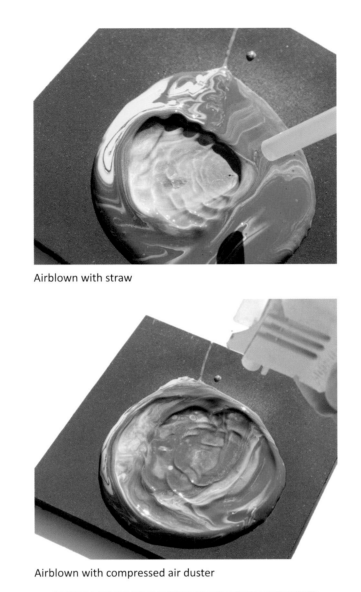

Airblown with straw

Airblown with compressed air duster

This piece was created using the "airblown" technique.

Dip and Peel

I sometimes use this technique when I have too much leftover paint or a large accumulation of paint runoff. Basically, you will load up a canvas with leftover paint. You can do this by pouring the paint onto your canvas, dipping your canvas, or a combination of both. One example of this technique would be to dip your canvas into the paint runoff and to add a complementary color on top of that. Whatever method you choose to cover your canvas will work.

From that point, you will set the painted canvas onto your work station and, with another prepped canvas, press into the painted canvas, making sure that the newly introduced canvas has been fully "dipped" into the painted canvas. Then, pull the second canvas off and reveal a whole new piece of art.

Example of the "Dip and Peel" technique using Yupo paper.

Marbling

Begin with a puddle pour utilizing a minimum of six to eight colors, making sure to add white in between every two to three layers (this helps prevent a muddy painting). Once you have all your paints poured, use your marbling tool and create your art. For demonstration purposes, I only used red, yellow, and blue in the picture below. I have a wide variety of tools I use to create marbling effects. Some examples of what you can use are homemade marbling rakes (wood with nails), drywall texture tools, shish kebab sticks, toothpicks, hair combs, and, my favorite, an angel food cake cutter.

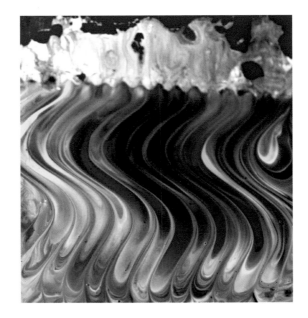

"Marbling" technique done with a drywall texture tool.

Negative Space Pour

Another cool technique is a negative space pour. A negative space pour is basically pouring a section of the canvas with color and leaving blank spots "negative space" within or around the composition. This creates a visually bold look.

Negative space pour on an Easy Flow Panel.

Spin Technique

Place your substrate on a rotating tray also known as a Lazy Susan. Then pour paint onto your substrate while turning or "spinning" the tray. This produces a swirly effect in the paint.

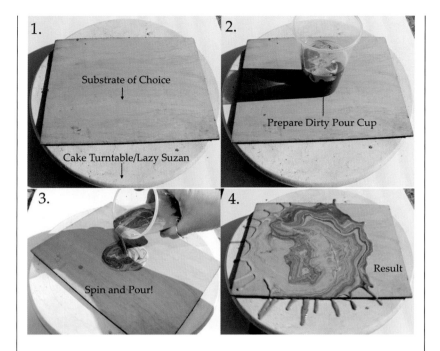

1. Substrate of Choice
 Cake Turntable/Lazy Suzan

2. Prepare Dirty Pour Cup

3. Spin and Pour!

4. Result

Swirl Technique

The "swirl" technique, popularized by artist Rita Karrip, is another fun approach to use. The swirl technique is prepared exactly like a dirty pour in terms of mixing and layering the paints and additives into one dirty pour cup. The manner in which the paint is applied to the canvas is comparable to a panning motion (like panning for gold) with really quick back-and-forth motions as the paint streams out of the cup and onto your canvas. This technique takes practice, but it creates a really cool effect.

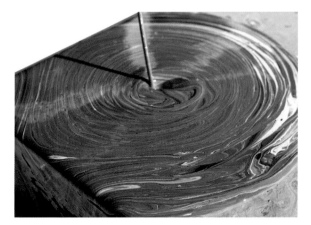

Swirl technique on Easy Flow Panel.

Hammer Technique

For the "hammer" technique, I use a plastic mallet. The majority of my work is done on wood, so the risk of damage

to my substrate is minimal. However, if you use canvas as your substrate, use caution because you can actually hammer right through your canvas!

I don't use this technique very often, but it is a useful method especially when you are unhappy with the way your painting looks. I utilize this technique by doing a complete swipe technique on my canvas. While the surface paint is still wet, I use a complementary color and pour about a three-inch puddle (see puddle pour technique), then I add another color directly in the center of that puddle. I usually do two or three puddles depending on the look I'm going for and the size of my canvas. Once I have the puddles poured to my liking, I hit the center of the puddles with my hammer. The paint goes flying and it can get quite messy, so be prepared for that in advance.

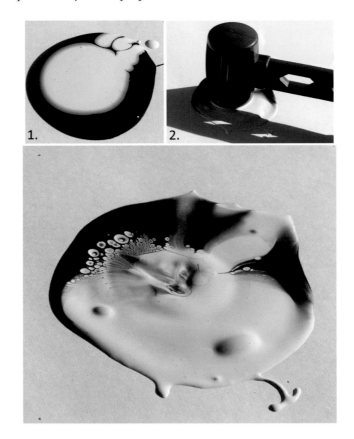

There are other techniques out there, but the methods listed in this book are the ones that I typically use. The amount of techniques that can be used are only limited by your own imagination. That is why I encourage experimenting as much as possible. The artwork pictured at the top of the next page are examples of hybrid techniques and experimentation.

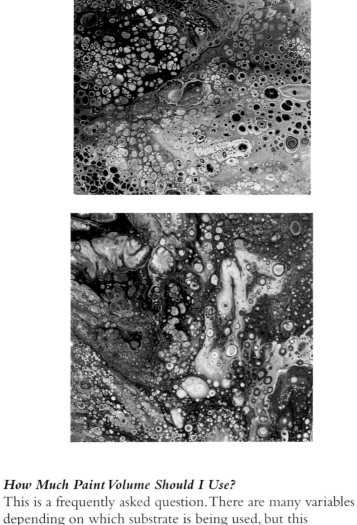

How Much Paint Volume Should I Use?

This is a frequently asked question. There are many variables depending on which substrate is being used, but this "unscientific" guide should prove to be helpful.

How Much Paint Should I Put in My Cup?

Paint Volume Per Canvas Surface Size

8 - 9 oz. → 15" x 15"

6 - 7 oz.
4 - 5 oz.
2 - 3 oz.

DIRTY POUR CUP

6" x 6"
15.24000cm

9" x 9"
22.86000cm

12" x 12"
30.48000cm

*Approximate surface volume. Amount will vary depending on depth of canvas and paint thickness.

CHAPTER 5

After the Pour

Drying

I recommend drying your art on a level surface for two to three days before touching it. There are times when I speed up the drying process by setting the art outside in direct sunlight, but that usually causes cracks in the paint and sometimes creates an undesirable look.

If you keep your art in an area that is room temperature or cool, has low humidity, and won't be tampered with, it should dry with no issues. I also flip a box over my artwork, covering it to keep dust and insects out of the paint while it's drying.

I use this bakery rack that I found at an estate sale for drying my paint-pouring projects. Anything will work, just as long as it is in a dust-free environment and it has a level surface.

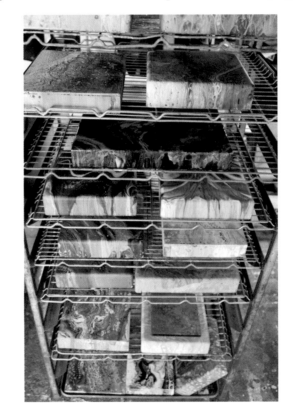

It's Dry, Now What?
Your piece has dried and looks great, so now it's ready to hang on the wall, right? Well . . . you could, but there are other possibilities to explore if you want to enhance your art and really make it stand out.

Make and Sell Prints

Take a photo or scan your art, then crop and edit with photo-editing software and make prints.

This is a lithograph copy of one of my pieces.

Rick Cheadle

Embellish with Art Markers

Add an artistic twist and enhance your art after it is dry with art markers.

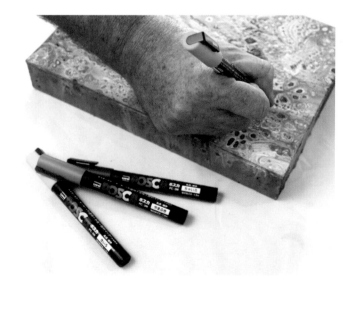

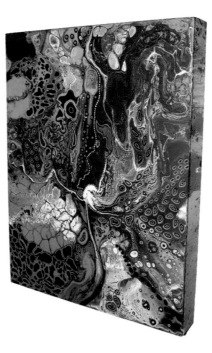

This piece features art marker embellishments.

Stenciling

After your paint pour has dried, you can use stencils to create unique mixed media art.

This piece was done with custom-made metal stencils.

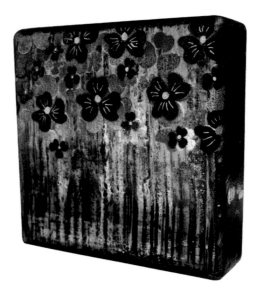

Swiped, then stenciled.

Turn Your Poured Album into a Clock

You can buy the clock mechanisms for under $10.

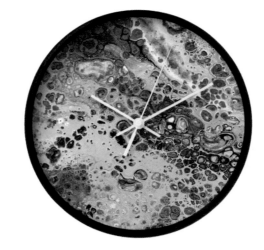

Paint-Poured Plexiglass – Lightbox

Pour paint on plexiglass and build a box around it. Drill a hole in the back and add a clip-on light. Make sure the box is deep enough, so that the light bulb doesn't come into contact with or get too close to the plexiglass. I recommend using a very low-watt bulb or LED lights for this. This is not recommended for children! This can be hazardous because it does get hot. Use caution.

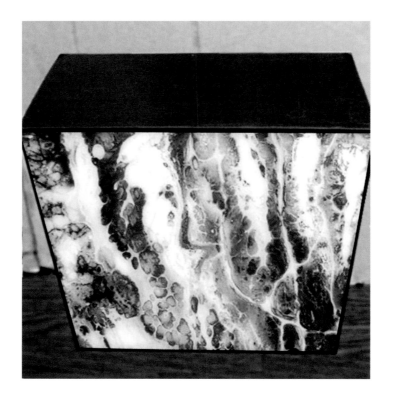

Unique accent lighting!

Chapter 6

Other Techniques

Dendritic Monoprinting

Place a piece of 8" x 12" glass (thrift store picture frame glass will work) under the wire basket that is used for holding your canvas. Do a couple of paint pours, making sure that the runoff paint lands on the glass.

Once you have enough runoff paint on the glass to cover it, brush the paint, covering the glass in one even layer. Then with the same size piece of glass, press it into the paint and apply just enough pressure to form a slight seal. (Too much pressure and you could break the glass.) Now, release the pressure and see the dendrites! To break the seal, carefully pry the two pieces of glass apart using a sharp knife.

Then take a piece of cardstock paper or Yupo paper and lightly press into the paint of one of the glass pieces. Carefully pull the paper off, and now you have a dendritic monoprint.

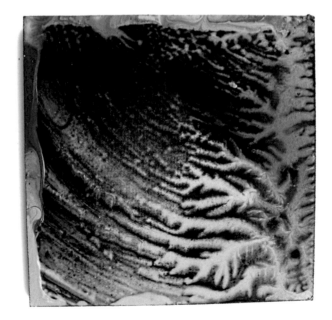

Helpful Tip: For demonstrations of the monoprinting process, search YouTube for "Dendritic Monoprinting"

Make Drink Coasters

If you use tiles as your substrate, you can turn them into drink coasters. All you need to do is add felt or cork on the bottom to protect the surface it will sit upon and apply a protective finish onto the artwork—I prefer a high-heat protective gloss. You can find tiles at your local craft store Standard size for coaster tile is four inches by four inches. I prefer using the porous/clay coasters, but anything will work, including wood. As always, I recommend a couple coats of primer before painting.

Step 1: Gather your supplies.

Supplies: E6000 Glue, Felt Tabs, and Tile

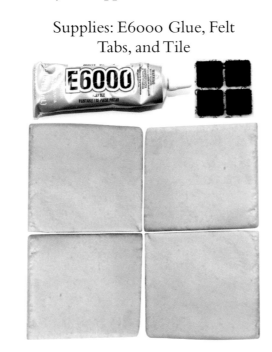

Step 2: Apply two coats of primer.

Step 3: Mix paint and pour onto tiles.

Align all four tiles and pour the paint.

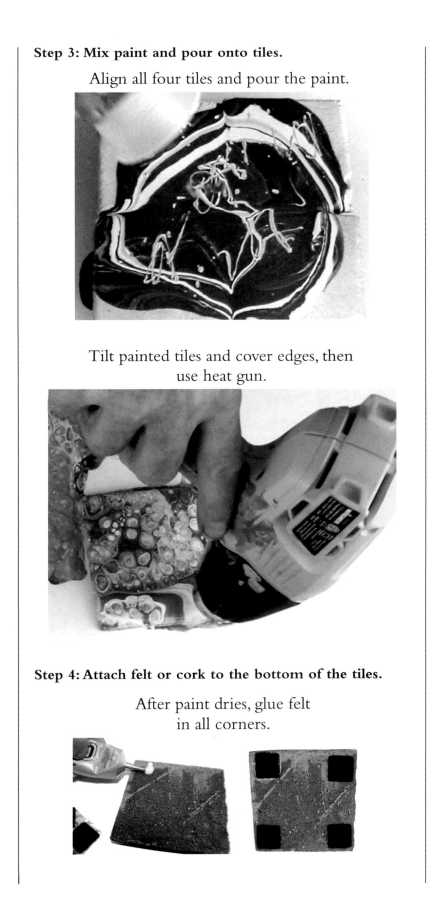

Tilt painted tiles and cover edges, then
use heat gun.

Step 4: Attach felt or cork to the bottom of the tiles.

After paint dries, glue felt
in all corners.

Step 5: Apply a top coat to protect your art.

Since these coasters will have hot beverages placed on them, it is essential to protect them with a high-heat protective gloss. I use Rust-Oleum Engine Enamel Clear Spray. It is made to stand up to temperatures of up to 500°F. (Hot beverages are generally served at temperatures between 160°F and 190°F.) Keep in mind, you must allow at least seven to ten days for the clear coat to fully cure.

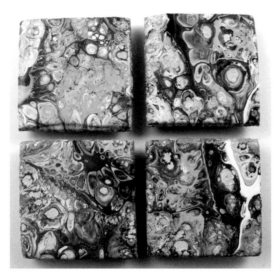

Making Things with Paint "Skins"

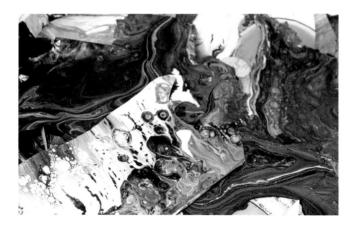

Mixed Media Collages

You can organize your paint skins into a color scheme you like and cut interesting shapes and patterns out and attach them to your canvas with an acrylic medium.

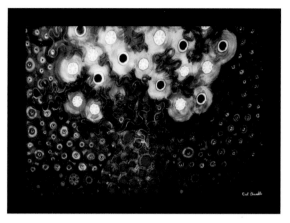

Mosaics

Cut your paint skins into small square pieces and arrange in interesting patterns and shapes and attach to your canvas with an acrylic medium.

Paint skins mosaic art piece.

Jewelry

This is a fun and profitable way to use your runoff paint. Once your "skins" are thoroughly dry, you can peel off the paper and use them to make these necklaces.

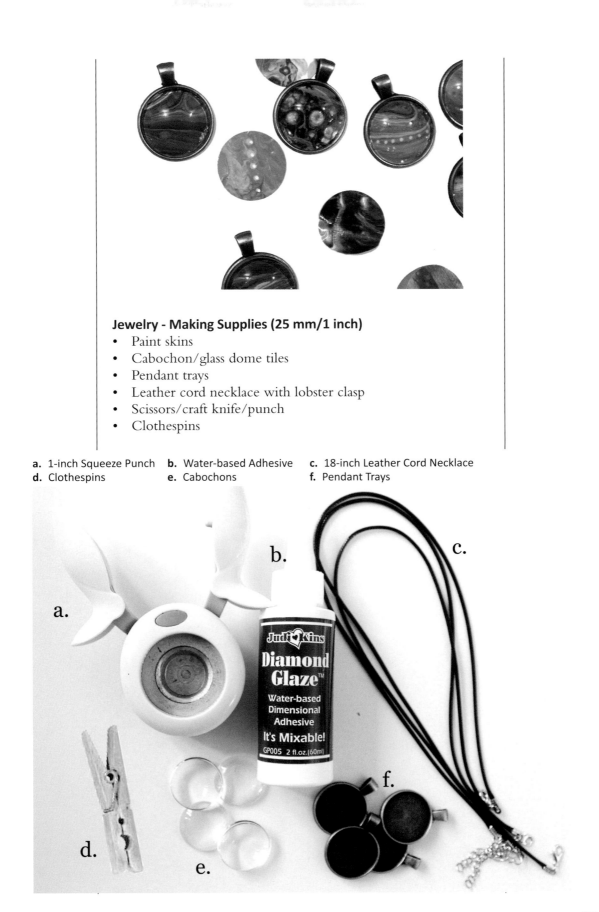

Jewelry - Making Supplies (25 mm/1 inch)

- Paint skins
- Cabochon/glass dome tiles
- Pendant trays
- Leather cord necklace with lobster clasp
- Scissors/craft knife/punch
- Clothespins

a. 1-inch Squeeze Punch **b.** Water-based Adhesive **c.** 18-inch Leather Cord Necklace
d. Clothespins **e.** Cabochons **f.** Pendant Trays

Step 1: Peel off paint drippings from freezer paper.

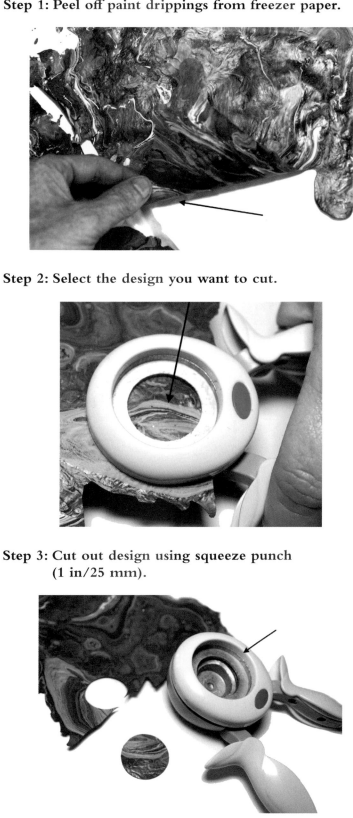

Step 2: Select the design you want to cut.

Step 3: Cut out design using squeeze punch (1 in/25 mm).

Step 4: Apply glue to the center of the pendant, covering about half of the circle.

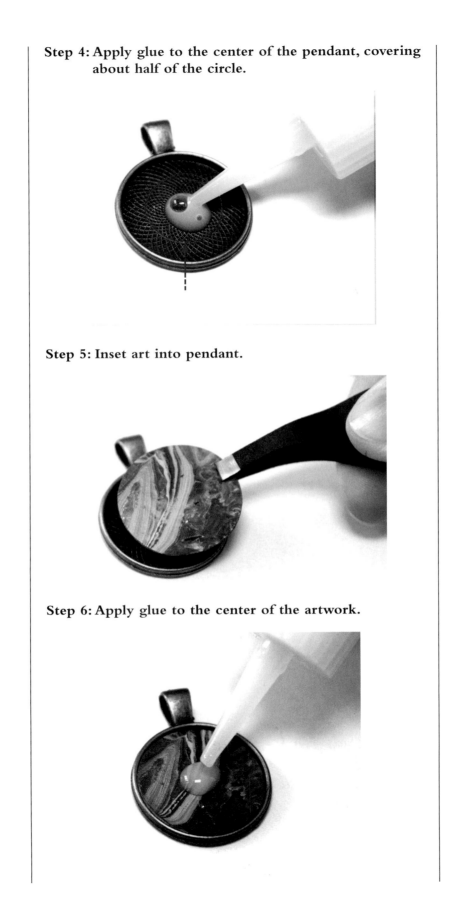

Step 5: Inset art into pendant.

Step 6: Apply glue to the center of the artwork.

Step 7: Place cabochon on top.

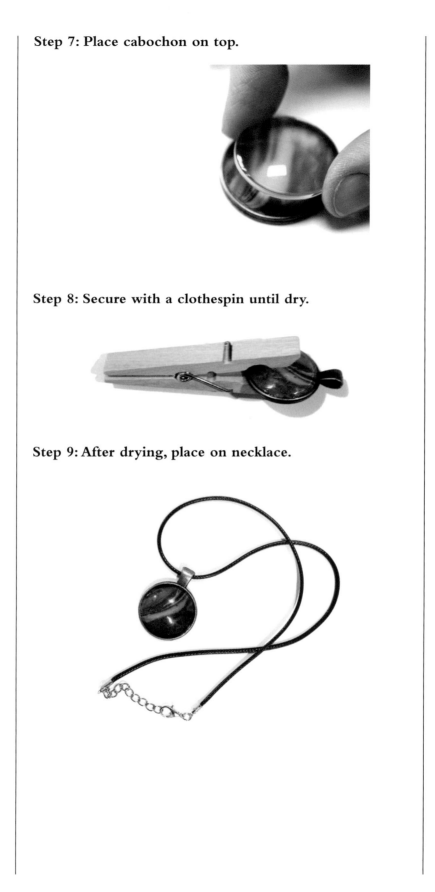

Step 8: Secure with a clothespin until dry.

Step 9: After drying, place on necklace.

CHAPTER 7

Paint Pouring on Furniture

Furniture Painting

When I paint pour on furniture, I do it more as an enhancement as opposed to an overall painting. However, you may prefer to completely cover your project. It all boils down to personal preference; this is how I paint furniture. Let's say you have an old end table that's seen better days. Overall, it is pretty sturdy, but there are scratches and dents, and it just plain needs a makeover. Turn drab into fab, one cup at a time.

Brush it off from top to bottom and underneath. Then wash it down thoroughly with a slightly damp cloth of warm water and Murphy oil soap. Immediately take another towel and dry it completely. Generally, I don't worry about scratches, gouges, and dents, so I rarely do any wood filling of any kind (if you prefer to do wood filling, etc., I would do that at this stage).

After the table has been completely wiped down and dried, do a complete sanding with heavy grit sand paper (60–80 grit), followed by 100 grit, and then finally with 150 grit. After you have sanded the table, use tack cloths and thoroughly wipe down the table.

Now, it's time to add primer. You can use a brush with primer or spray it on. I prefer to spray it on because it covers more evenly and it dries much more quickly. I usually put on two to three coats of primer (lightly sanded in between coats with 180-grit sandpaper, then wiped with a tack cloth). After the final coat of primer has been applied, let that dry and start mixing your dirty pour cups. The end table example I am using has a table top surface area of eighteen by twenty-two inches. This will require two 9-ounce dirty pour cups filled with paint.

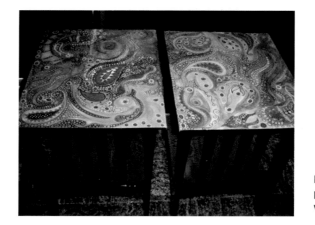

Pair of end tables, paint-poured and embellished with art markers.

Once your dirty pour cups are mixed and filled, cover them and let them settle to ensure there are no air bubbles in the mix. Meanwhile, paint the base of the table. Flip the table upside-down onto a soft surface or a towel. My base color preference on nearly all my furniture makeovers is flat black. I prefer this because it makes the paint pour colors "pop," and it usually only requires one to two coats. I also prefer the spray-on paint as opposed to the brush-on.

Once you have painted the base of the table (which includes all four sides and legs), flip it back over to its normal position. After the base coat is thoroughly dry, use painter's tape and tape off the edges of the table top—this will prevent the paint drippings from running over the edges and onto the base that was just painted.

Once the tape is in place, begin your paint pour onto the table top. Any of the methods discussed earlier in this book could be used with a little adaptability. I usually do pours, a pour and swipe, or a variation of both techniques. Whatever you decide, it is important to let your piece dry thoroughly in a dust-free and level area.

Let your furniture projects sit for five to seven days after pouring before removing the tape. Once you remove the tape, you can touch up any areas that need any attention and decide if you want to add embellishments or if it is ready for a protective coating.

Typically, I add embellishments to my pieces (I use Posca Art Markers). Then I spray with a few coats of clear gloss, and it's good to go. You can stop there and have a great piece of functional art or you can take it up a notch by adding a resin finish to the paint-poured surface. In this case, I recommend you let the table sit for an additional three to four weeks. This will ensure that the paint is fully cured prior to adding resin.

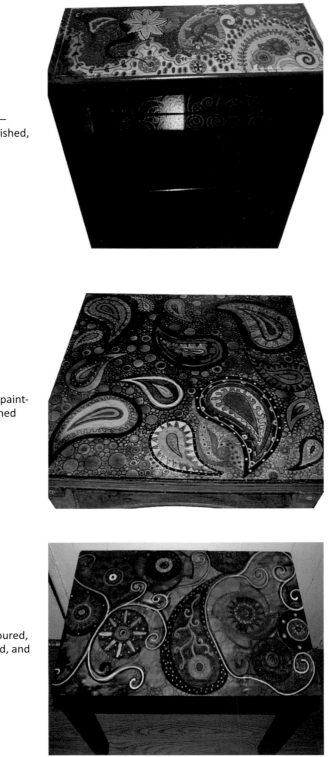

Bookshelf makeover—
paint-poured, embellished,
and resin finished.

Salvaged end table—paint-
poured and embellished
with art markers.

Coffee table—paint-poured,
art marker-embellished, and
resin coating.

CHAPTER 8

Protecting Your Art

Preparing for a Protective Finish

You may or may not choose to complete your artwork with a finish. Every artist has their own opinion on this. I personally like to have a sheen to my artwork, and I like the idea of the work being protected from pollutants, debris, potential scratching, etc. Therefore, I always finish my work with a gloss finish. I also have my pieces finished with epoxy resin.

Clean Before You Protect
If you do decide to have a protective finish applied to your piece, make sure it is clean! If you use any kind of oily additive in your paint pouring, it is essential to remove it from the surface prior to sealing your work.

To remove the oils from the surface, you can use warm water and dish soap. Make sure your painting is thoroughly dry before cleaning. I recommend waiting one to three weeks depending on your environment.

Dab your paint surface lightly and frequently check that there is no color (paint) transfer. After going over the surface, use a clean towel to thoroughly dry. Repeat, if necessary. Another option is cornstarch or talc powder followed by a tack cloth. I personally prefer the dish soap method.

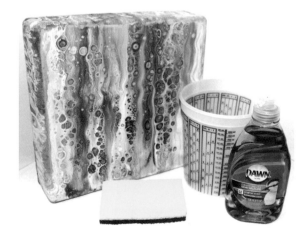

Something to Consider Before You Apply Varnish or Resin

If your work is archival and you want the ability to clean it years down the road, I recommend applying an isolation coat. An isolation coat is a medium between the art and the varnish. It creates a "separation layer" between the two. If you are not concerned with being able to remove varnish five to seven years down the road, you can skip the isolation coat.

While there are several products that can be used for the isolation coat, my favorite is GOLDEN Soft Gel Gloss Gel, but a water-based gloss varnish will work. Just apply two thin coats then let it cure.

The following list is what I have discovered over the years to be the pros and cons of the types of varnishing (brush or spray) that you can apply to your art.

Brush-On Varnish

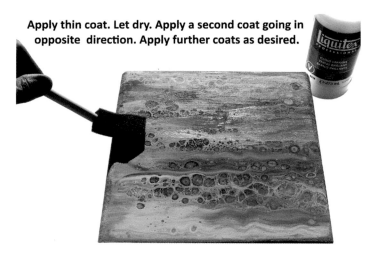

Apply thin coat. Let dry. Apply a second coat going in opposite direction. Apply further coats as desired.

Advantages:

- UV protection
- Stays clean longer
- Evens out the sheen of the work
- Protection from scratches and scuff marks

Disadvantages:
- Creates brushstrokes
- It is hard to get an even coat on large canvases
- It can totally change the look of a piece and not always in a good way

Spray-On Varnish

Apply thin coat. Let dry. Apply a second coat going in opposite direction. Apply further coats as desired.

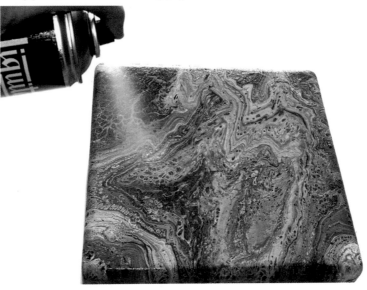

Advantages:
- No brushstrokes
- Stays clean longer
- Less mess/easy cleanup
- Evens out the sheen of the work
- Easier to apply to substrates up to 3' x 3'

Disadvantages:
- Fumes require working outdoors or in a well-ventilated area
- More expensive
- Becomes a dust magnet while drying; cover carefully

Helpful Tip: If you have never used varnish before, practice on inexpensive canvas or scrap wood to decide what look you prefer among matte, satin, gloss, or resin.

CHAPTER 9

Selling and Pricing Your Art

The steps below are some recommended steps when you consider selling and pricing your art.

Step 1: Set goals.
Do you want to be a full-time artist? Do you want to make enough to pay a few bills a month? Or are you happy just making enough money to buy more paint supplies? Write down your goals! Your motivation in the next steps is based on how eager you are to achieve them.

Step 2: Research what is selling.
Go to websites that sell art similar to your style. Search for top-selling items. Are they selling? Maybe you need to adjust. Can you produce similar works to what is selling? Create your own spin on it and see how it turns out.

Step 3: Show off your art!
When you have a large enough portfolio to showcase, put it out there for the world to see. This will give you instant feedback on if you are on the right track . . . which leads into the next step.

Step 4: Build your social network presence.
Upload your works as fast as you create them. The thing to remember is nobody knows who you are yet. You have to be out there. Pound the pavement. Be a self-promoting machine. I know it's not fun, but it is essential. You can be the greatest artist on the planet, but if you're not exposed to the world, who will even know that you make art or even exist?

Step 5: Become part of a community (blogs, social networks, local guilds, etc.).
Being connected to like-minded people can only help you reach your goals. My mantra when I first started pursuing art as a full-time profession was "Think in terms of *networks* instead of *net worth*," and the money will come later. Be a nice person, be helpful, and be caring. BE REAL! Don't be phony. Remember: the more you give, the more you get.

Suggestions for where to sell your art:

- Galleries
- Local stores/gift shops
- Arts-and-crafts shows
- Flea markets
- Consignment shops
- Online art markets (Etsy, Inc., and others)
- Craigslist, Inc.
- eBay, Inc.
- Your own online store
- Garage sales
- In-house sales/art parties
- Arts festivals
- Farmers' markets

Pricing Your Art

Decide what you feel your time and skills are worth. Do you want to make so much per hour? Per day? Per week? Once you determine that value, calculate the costs of materials. So, a sample breakdown would look like this:

Now, this is a simplistic formula to get you started. There are other things to consider, but this is how I priced my art when I first started, and it worked out fine.

Of course, the more established you become as an artist, the more the market will begin to determine your market value. Supply-and-demand is something to consider when you reach that level. For example, if you only release one piece of art to the public per year and you are an in-demand artist, you can charge a premium. It's all about the market and where you currently fit within it.

I want to be paid $50 per hour for painting, so if a piece of art takes me an hour or less to create, I add $50 plus the costs of materials. Let's say the cost of materials is 25$. So, the price I would charge is $75.

The following diagram may be helpful when deciding on how to price your art. This is how I have priced my art for nearly a decade, and I now have thousands of happy clients.

Since I discuss in this book how to create art with both inexpensive/nonarchival and professional/archival supplies, this chart gives you options in terms of how much to charge for your works.

I offer my nonarchival work for a huge discount compared to the fine art pieces. I like to do this because not everyone can afford a fine art piece, and for that matter, not everyone necessarily cares about the longevity of a piece. Some will just want a piece to decorate a room or to give a piece of art as a gift.

Something beautiful that can be purchased for pennies on the dollar can be compared to fine art pieces sold in galleries. I simply explain the difference between archival and nonarchival art and the reasons why the prices vary, then let the customer

decide which is the appropriate option for them. This way you're not losing potential customers over price; you have art to offer for all budgets!

Cheadle Designs
Art Price Tiers for Paint-Pouring Works

Entry Level	Collector	Fine Art Collector
Home Decor Art	**Glicée Prints**	**Original Art**
using nonarchival materials	using archival pigments and substrates	using only archival materials
$	**$$**	**$$$**
*Nonarchival *Recycled materials used	*Archival *Only quality materials used	*Archival *Only quality materials used

Please Note: Since there is currently no data about the use of silicone or dimethicone as additives in paint pouring, the archival quality of your work cannot be ensured when using these ingredients. It is up to you as the artist to decide how to address this going forward.

Giclée Printing

Technology has advanced so much recently that it is possible to have a high-resolution print made of your art that could actually last longer that the art itself. Giclée printing uses pigment based archival inks and is printed on archival substrates to ensure your art will last one hundred or more years without noticeable fading.

If you have created a piece with nonarchival materials but it really turned out nice and you want to offer it as an archival piece, giclée prints are an excellent option.

To have a giclée made of your art, you'll have to capture a high-quality photograph of your art or have it digitally scanned. The best way to get a color-correct match is to deliver your art to a giclée creator in person or via mail.

It can be said that a giclée print is not an original piece of art. While this is true, you can make it original. You can embellish the giclée print by adding little touches of paint to accent certain areas or add paint wherever you wish. You are adding

your own personal touch to make it unique to that particular print! I do this often, and I sell them as hand-embellished art prints or original-mixed media art.

It's all about being ethical and providing full disclosure to your collectors/customers. Explain to them how the art was made, what materials were used, and why you deploy your particular pricing structure.

An informed collector will become a loyal collector.

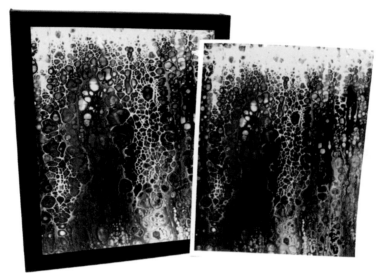

Original Framed Art **Giclée Print**

Why I Recommend Giclée Prints:
- Archival
- Fantastic print quality
- Can be reproduced at any size
- Can be printed on a variety of substrates
- Offers an affordable option to higher-priced originals
- Can help attract gallery interest in your originals
- Comes with certificate of authenticity

CHAPTER 10

Resin Finish

The majority of my art is finished with high-gloss epoxy resin. This is not a requirement, just my personal preference. I love the look and feel of epoxy resin. It's amazing how it makes the colors in the artwork pop and takes the work to a whole new level.

I have experimented with several brands of epoxy resin, but my go-to brand is ArtResin. Their epoxy resin was literally made for artists. There are no VOCs (Volatile Organic Compound), no fumes, and they use the most efficient yellowing protection on the market—HALS (Hindered Amine Light Stabilizers).

Epoxy Resin Supply List
- Two-part epoxy resin (resin and hardener mixtures)
- Cups and containers to mix and pour resin
- Spatula or putty knife for spreading the resin
- Stir stick for mixing resin
- Brush—a small brush is useful for covering the edges and crevices.
- Level for ensuring a level canvas prior to resin application
- Heat source to pop air bubbles (I use a heat gun or a chef's torch)
- Disposable gloves
- Eye protection
- Painter's tape
- Stands to hold canvas up above work table

Applying the Epoxy Resin
Prepare
You can access the resin coverage calculator on the ArtResin website to determine how much you'll need for your project. Also, this would be the time to make sure your canvas is level and elevated a couple of inches off your work space. This would also be the time to apply painter's tape to the edges of your canvas, if you don't want any resin drips.

Using eye protection and gloves, mix equal parts resin and hardener into a cup or container and thoroughly mix for three minutes, making sure to scrape the bottom and edges of the cup while mixing. I have learned the hard way that it is better to mix too much rather than not enough, so I would mix a little more than you think you will need.

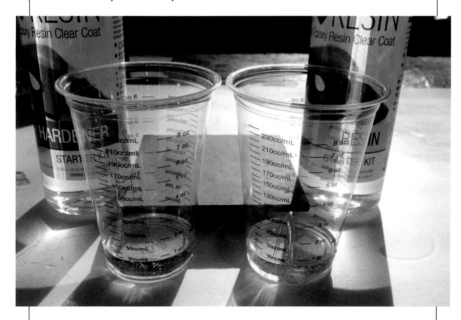

Pour

Begin by pouring the resin in the center of the canvas, then spread the resin all over the canvas with a spatula or putty knife. You will probably see air bubbles in the resin—this is normal. Many will pop on their own, but all you have to do is apply heat with a heat gun or a torch. Use caution when handling any heat source.

After about forty-five minutes or so, you can scrape the underside of your canvas to get rid of any resin drips. This makes the final cleanup much easier. If you plan on reusing the mixing tools for future resin projects, it is important to wipe them down as soon as possible with a towel before the resin dries.

Let Sit

Once you have your artwork covered with resin, it is important to leave it alone for at least twenty-four hours. I use a plastic tub or a cardboard box that I flip upside-down and over the artwork to protect from dust and debris. Your art will be fully cured within seventy-two hours.

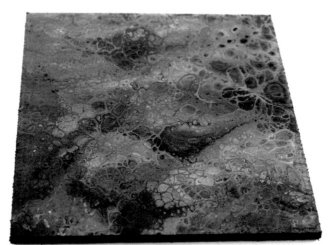

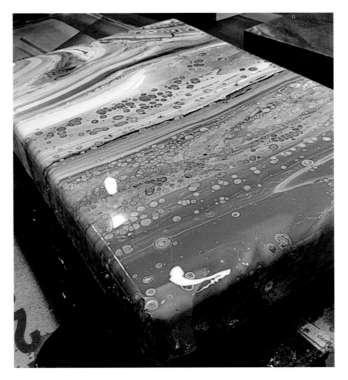

Fully cured paint pour with epoxy resin finish.

Glossary of Terms

Acetate Sheet – Used for protecting art and transparent mixed-media applications. I sometimes also use it as a swiping tool.

Analogous Colors – Three adjacent colors on the color wheel.

Archival – Durability or staying power.

Auto Lubricant – A type of silicone spray that I add to my mix to help produce cells.

Binder – A substance that holds pigments together.

Bleeding – A dark color seeping into a lighter color.

Blending – Joining two colors together with a smooth gradation.

Blooming – A dull, hazy, white effect that occurs on a varnished surface when exposed to moist or humid conditions.

Bookbinders Glue – An archival alternative to use as a pouring medium.

Cells – The cellular designs that are created during the pour.

Chroma – The colors' intensity.

Coconut Milk Oil – An additive to help create cells.

Color Palette – The colors selected to be used in your artwork.

Complementary Colors – Opposite colors on the color wheel.

Consistency – The fluidity of the paints.

Crazing – The cracked or alligator-skin look on the dried surface of a painting.

Dendritic Monoprint – A type of art created by squeezing two pieces of glass together (with paint in the middle), then dipping paper on the painted glass surfaces after they are separated.

Dimethicone – An additive to help create cells. Found in hair and personal lubrication products.

Dirty Pour – Combining two or more paints into a single cup.

Easy Flow Panel – Cradled, rounded-edge paint-pouring panel.

Emulsion – Akin to mixing opposites like oil and water (think vinaigrette).

Flip Cup – The flip cup technique is more of an approach of how you get the paint on the surface of your canvas. In short, you flip the cup over. See details in Chapter 4.

Floetrol – A paint conditioner. It helps to improve paint flow while maintaining the quality of the paint.

Foam Board – I purchase these at a dollar store. It is polystyrene foam core that is laminated with kraft paper. I use the boards as a base to catch the paint runoff. After the paint dries, the kraft paper peels off from the foam board. I use these peels in jewelry making and other mixed-media works.

Freezer Paper – I use this (shiny side up) to collect paint drippings to use in other projects.

GAC 100 – A very flexible polymer medium that I occasionally use as part of my Fine Art Mix in place of GAC 800. Manufactured by Golden Art Supplies.

GAC 800 – I use this as part of my Fine Art Mix. It is a finishing medium that helps to prevent cracks and crazing. Manufactured by Golden Art Supplies.

Gesso – Artist's primer; prepares your substrate for accepting paint.

Giclée Print – A type of printing process that uses pigmented archival inks and archival substrates.

Gloss Medium – Helps increase color intensity, gloss, and ease of flowing.

Gloss Varnish – Protects painting with a glossy sheen.

Isolation Coat – A coating that serves as a barrier between the paint surface and varnish.

Knockdown Knife – Drywall-finishing tool used for swiping; discussed in Chapter 4.

Lacing – The web-like pattern formed in the paint after a pour.

Lightfast – Will not fade because of sunlight.

Matte Finish – Not shiny or glossy; flat.

Mixed Media – A mixture of techniques, materials, and mediums used in an artwork.

Mixology – The term I use to describe my various mixes.

Monochromatic – Tones, tints, and shades of one color: tone is color plus black and white; tint is color plus white; shade is color plus black.

Nonarchival – Impermanence or unreliable staying power.

Opaque – Covering up. Unable to see what is underneath.

Pigment – The substance that makes the colors of the paints.

Permanency – The lightfastness of a color.

Pipette – A dropper for liquids.

Pooling – When your paint collects in one area and doesn't spread out.

Pouring Medium – Colorless paint.

Primary Colors – Red, yellow, and blue.

Primer – Substance applied to substrate to prepare for painting.

Puddle Pour – The layering colors on the canvas in one or more puddles that allow the paint to flow out and/or into one another.

PVA Glue – Colorless, odorless glue that doesn't break down over time. An archival alternative to pouring medium.

Resin – A two-part solution that protects your art with a glass-like finish.

Secondary Colors – Purple, orange, and green.

Silicone – An additive to help create cells. Found in various products like treadmill lubricant, auto lubricant, and others.

Substrate – A surface that paint will be applied to.

Swipe – A technique in which one color is moved over another color.

Tertiary Color – Colors that are achieved by mixing a primary with a secondary color. Examples: amber/marigold (yellow-orange), magenta (red-purple), chartreuse/lime green (yellow-green), teal/aqua (blue-green), vermilion/cinnabar (red-orange), and violet (blue-purple).

Translucent – Can partially be seen through (frosted look).

Transparent – Can be seen through; clear.

Value – The lightness or darkness of a color. Examples: white is high-value, and black is low-value.

Varnish – A transparent, protective finish.

Yupo Paper – Waterproof and stain-resistant artist paper.

Frequently Asked Questions

Q. How long will a painting last that has Elmer's Glue in the mix?

A. The fact is that it is too soon to know. To my knowledge, using PVA as an inexpensive alternative to a pouring medium is fairly new to fluid art. There is no way to know what the condition of the painting will be twenty to thirty years down the road. This is why I recommend using an artist-quality pouring medium if you plan on selling your works. My advice is to hone your skills and develop your paint-pouring chops with PVA, then when you are ready, use the best quality (archival) ingredients you can afford.

Q. Can I pour on glass, wood, or ceramic tiles? If so, should I use a primer first?

A. Yes. I have poured on all of those with no problems. I use KILZ MAX Latex Primer/Sealer.

Q. Can you set hot drinks on your coasters?

A. Yes, I protect them with a high-heat protective gloss and let them cure for a minimum of seven days.

Q. Is an isolation coat a requirement?

A. It is not required, but I do it, and I recommend it to those who want the ability to remove and reapply varnish years down the road. I recommend researching "isolation coat in acrylic painting" on the web and deciding for yourself.

Q. How long does it take to dry?

A. There are many variables: the type of paints you use, the type of medium, and even the type of water used in your mix will all factor in drying times. Also (maybe the most significant variable), the temperature/humidity/environment in your studio. For myself, the average drying time for paint pours is three to five days. The average curing time is four to six weeks.

Q. Why do my pours dry muddy?

A. There are many possible factors. I suggest avoiding complementary colors in succession when preparing a dirty pour cup. I like to add a layer of white in between every two or three colors whenever possible and make sure not to stir too much, if at all.

Another cause could be using low-quality paints or using too many opaque colors on top of one another. Also, make sure you are working on a level surface, and if you are using a canvas,

make sure it doesn't sag in the middle. Canvas sagging allows the paint to pool in the middle and can create a muddy mess and/or crazing. This was an all-too-common occurrence when I first started paint pouring.

Q. What causes cracking and crazing?
A. Here are some things to consider:
1. Is there too much water in your mix?
2. Are the paint consistencies the same in all colors?
3. Are you using different brands or types of acrylic paints within the same dirty pour cup?
4. Did you get the surface too hot while heating?
5. Is there too much paint on the surface of your canvas? Is the paint "pooling"?
6. When adding heat, make sure you move the heat source very quickly and briefly over the surface to avoid the paint surface from forming a film.
7. Slow and steady drying works the best: you want the interior of the paint to dry before the outside. If possible, cover your art with a box or plastic tub or bin while it is drying. This will slow the drying process and will also prevent bugs and other debris from getting on your painted surface.
8. I recommend using GOLDEN GAC 800 in your mix.

Q. Can I use Tempera or poster paint?
A. Yes, you can. I have used both. I suggest using GAC 100, GAC 800, or Liquitex Pouring Medium, and use very little water.

The Last Word

The information covered in this book are the techniques I've developed over years in the art world. These techniques work well for me, but that doesn't mean they are the only options. I am equal parts fan and artist. I am aware of and in awe of some of my contemporaries in the paint-pouring world. I must acknowledge them here and now and search for them on YouTube. All of these artists are passionate about their art, about experimenting and pushing the boundaries. They are artists who can't wait to show the rest of us what they're learning.

My favorite (and my mentor) is Annemarie Ridderhof, from the Netherlands. Annemarie is fearless in her experimentations with the materials we use in creating our paintings. Her enthusiasm for this art form is contagious, and her drive to share what she learns has garnered her channel a throng of loyal subscribers (including me). Her inspiration is what drove me to go all in on pursuing this as an actual art form and not just a tool for my mixed-media works.

The second artist I want to mention is Caren Goodrich. Caren urges her viewers to "... grab some paint and let's have some fun!" Caren has been making art for a number of years and has brought all those skills with her to her YouTube channel, *Caren Goodrich*. When you visit her site, check out her flower paintings on the back wall of her studio. Would you believe those were "painted" with a hammer?!

There are many more Youtube channels I like to watch: Sarah Fezio, Ann Osborne, Carl Mazur, Sauve Arts, Deliberately Creative, MelyD, Danny Clark, Nicky James Burch, and Myriam's Nature. They are all great!

If you find another artist's "recipe" that works better for you, by all means, use it! My way is *not* the only way. The techniques I covered in this book are the ones that work for me. All of the tools and supplies I have recommended are the actual tools that I personally use. That doesn't mean that they are the only tools out there. During your research, you may find other resources to help you along the way. Follow your creative spirit wherever it leads you.

What this book has covered is basically a day in the life in my studio. I didn't hold anything back. I shared with you everything I know about paint pouring that delivers consistent results

for me and my students, and I'm sure they will work for you, too. However, it is up to you to do the work and apply the techniques . . . and, most important, experiment! Paint pouring does have a learning curve, but it is so worth it!

I hope this book pumped you up and got you excited to go to your studio and create a masterpiece! The next step is to put all of the information in this book to work and start pouring.

Thank you, and Happy Pouring!
Rick Cheadle
www.rickcheadle.com

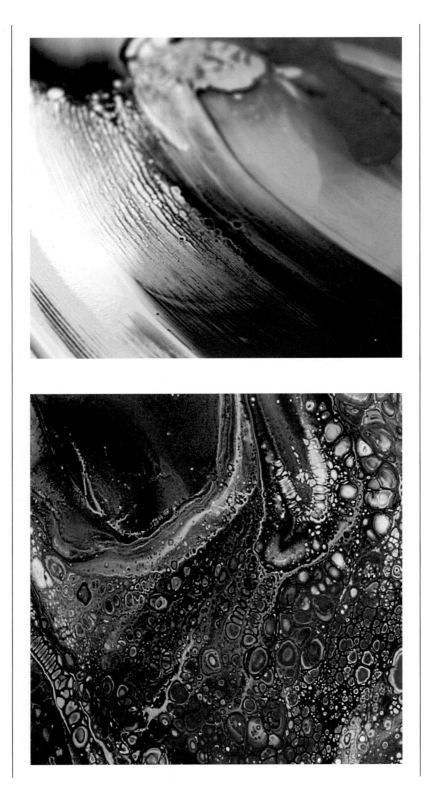

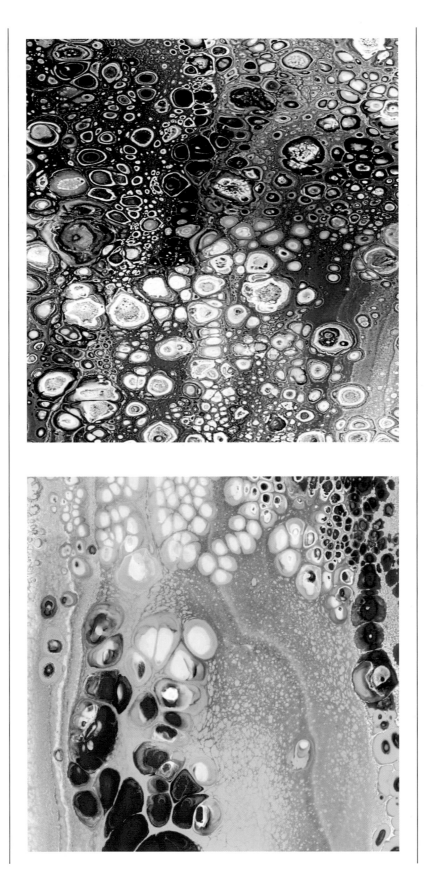

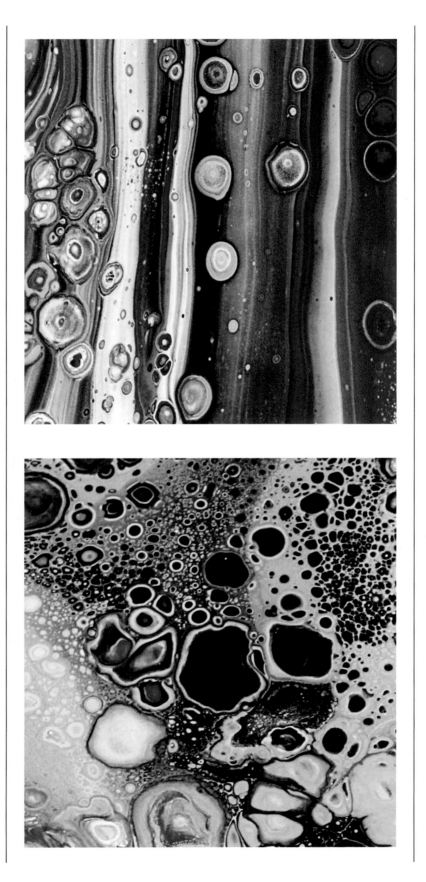

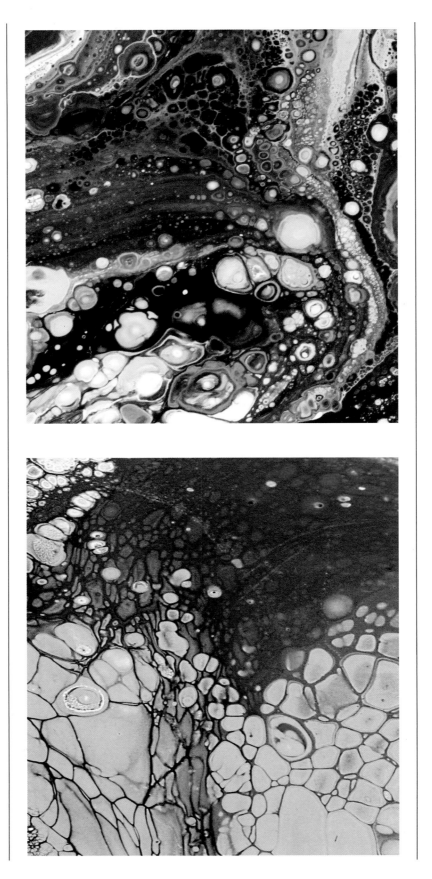

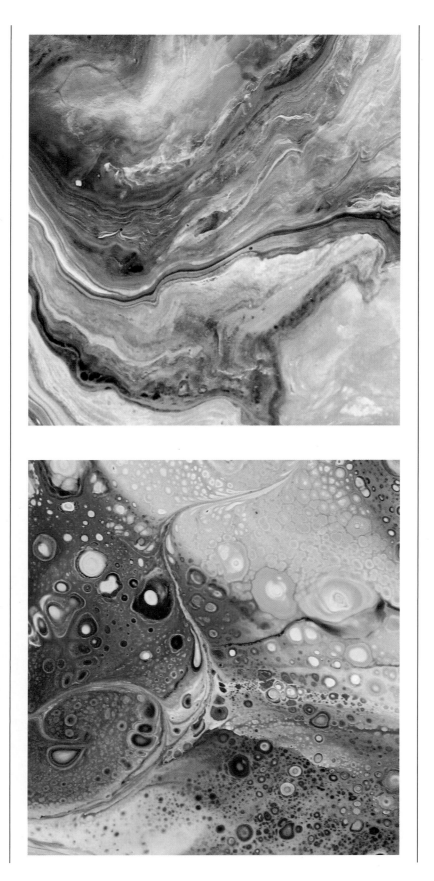

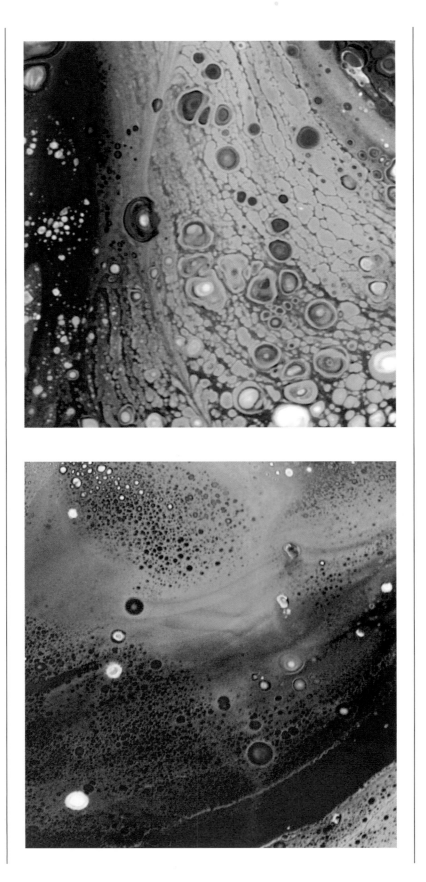

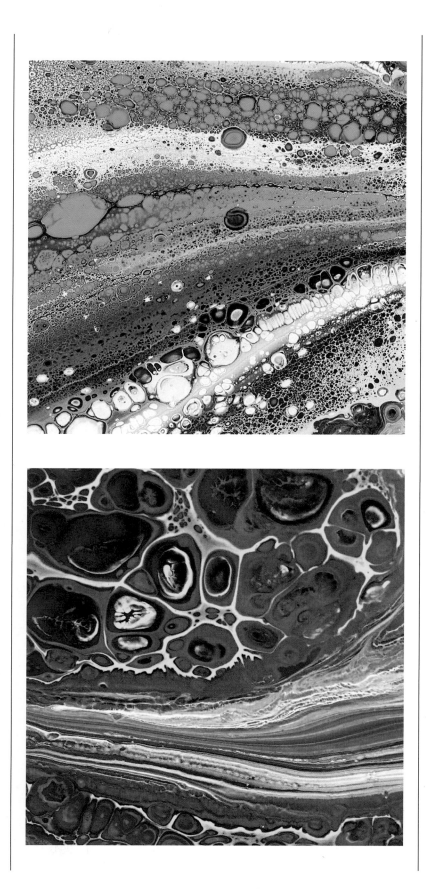

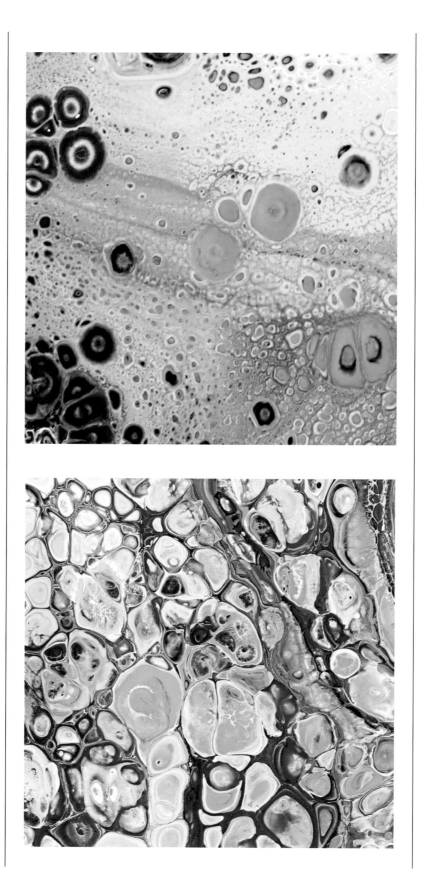

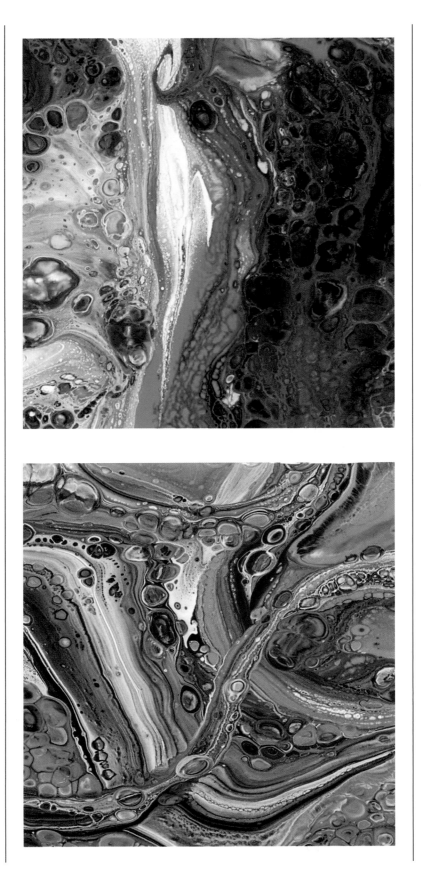

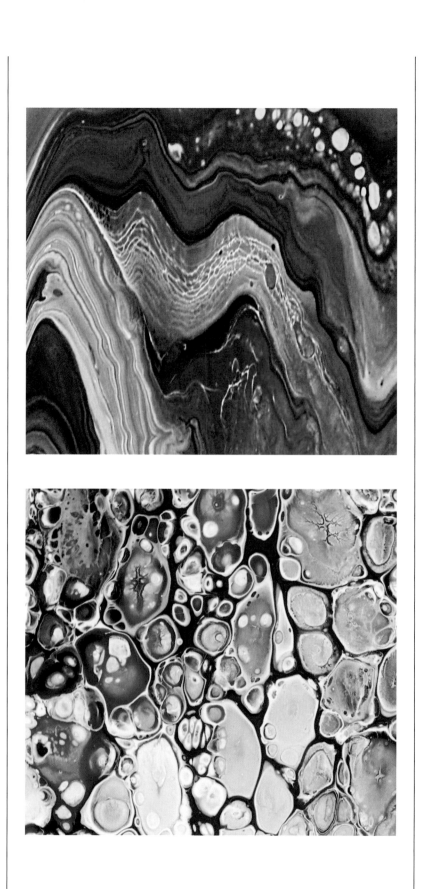

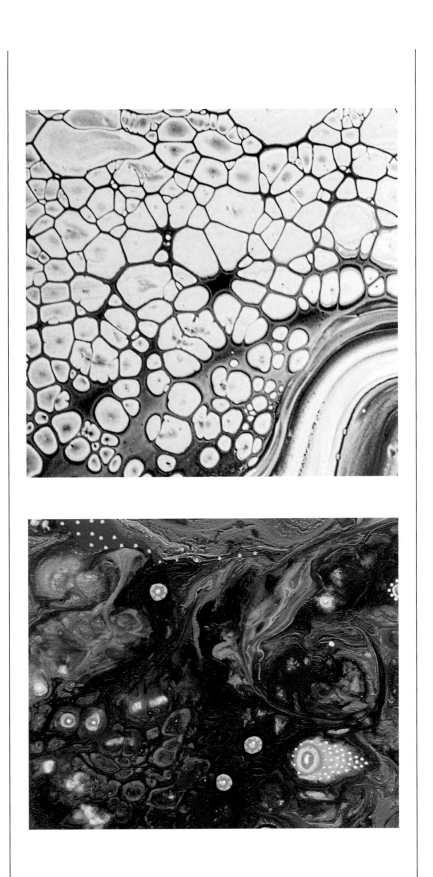

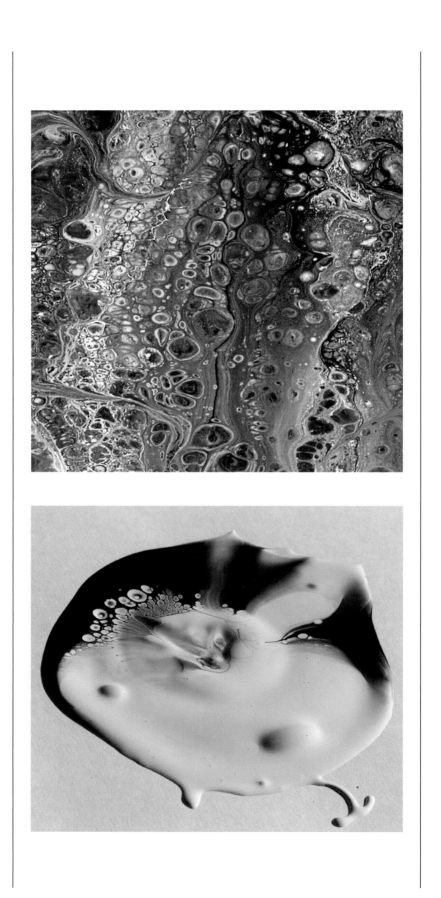

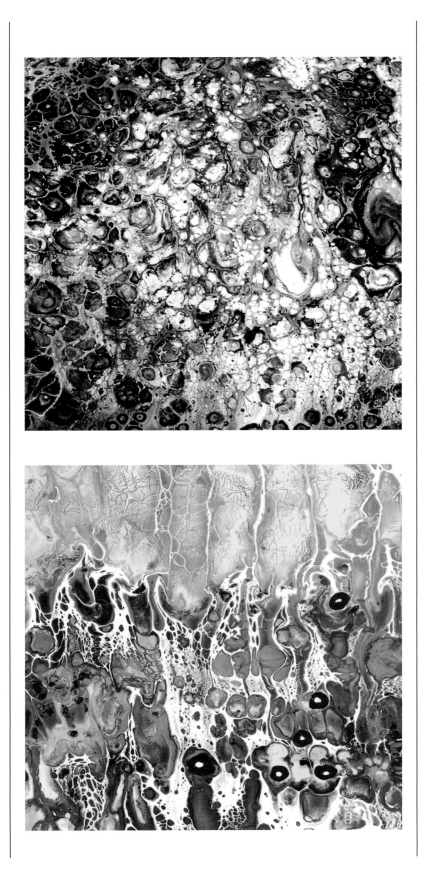

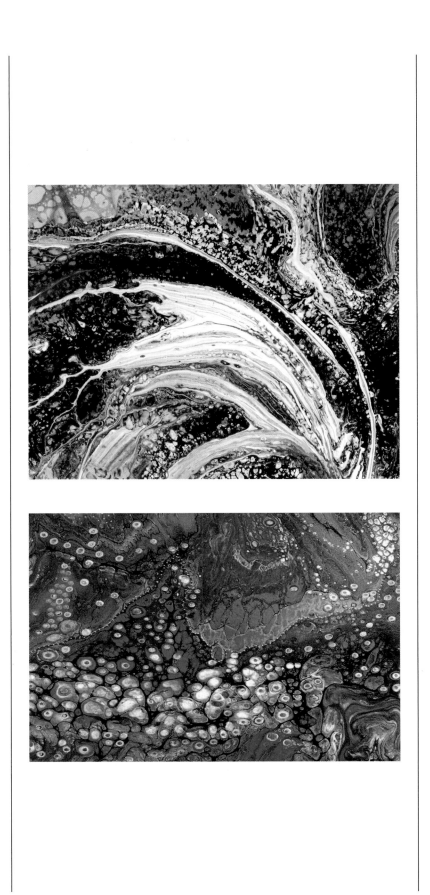

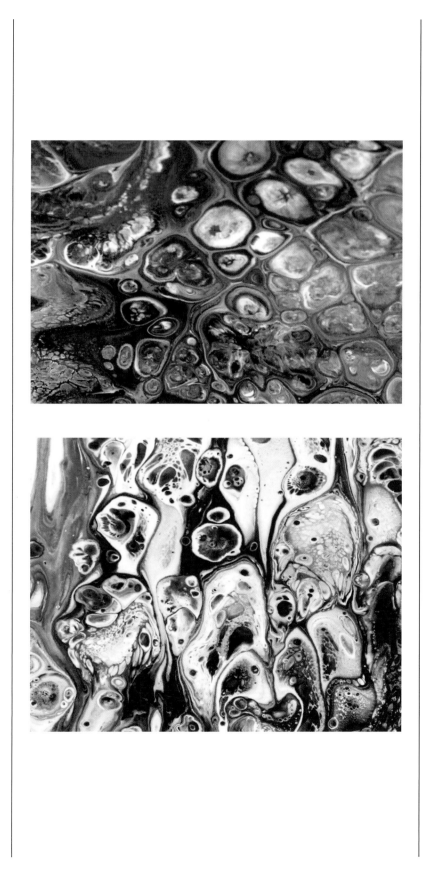

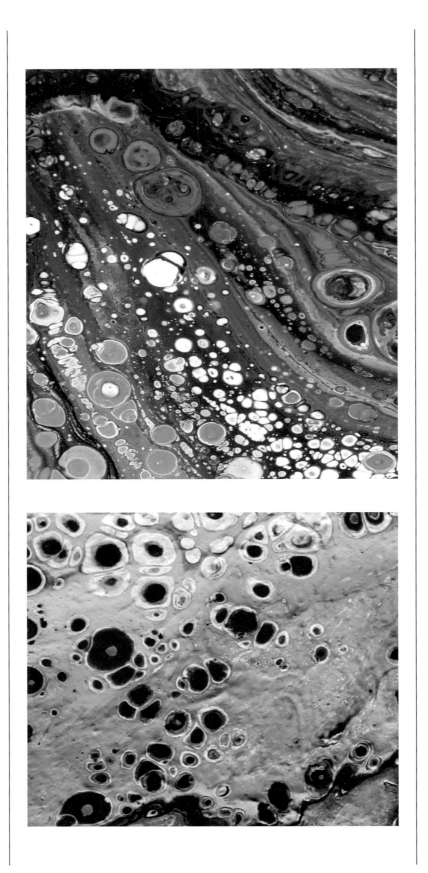

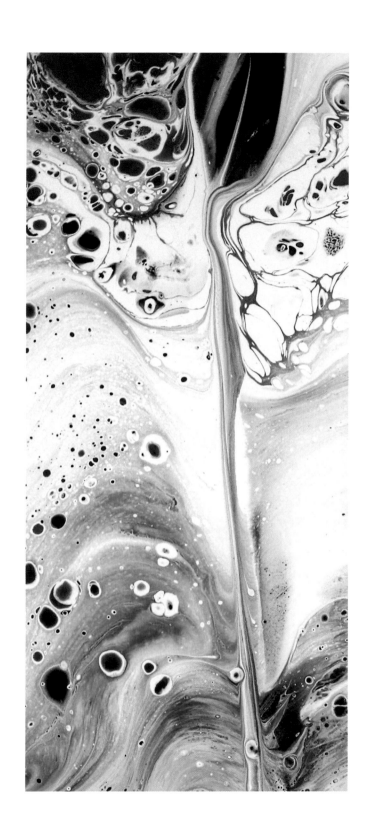

About Rick Cheadle

Rick Cheadle is a self-taught mixed-media and abstract artist based in Michigan. He draws inspiration for his varied creations from midcentury art and design, including abstract expressionism. His portfolio includes large-scale wall art pieces, wall sculptures, found-object mobiles, as well as a plethora of mixed-media and fine-art works. Using his natural sensitivity to color harmony and his keen attention to detail, Cheadle creates a variety of custom-designed pieces in demand for homes and businesses around the world.

Other Books by Rick Cheadle:

Daily Journal and Goal Setting: Happy Life Quest: An Inspired Life Through Journaling

Reselling: The Art of Flipping Art: Buying and Selling Art for Huge Profits

Photography Made Easy: The Beginners Guide to Learning Digital Photography in A Weekend

Abstract Floral Designs: Meditative Coloring for Stress Relief and Fun Zen Time Colorscapes